IMAGES
of America

Around
ST. MICHAELS

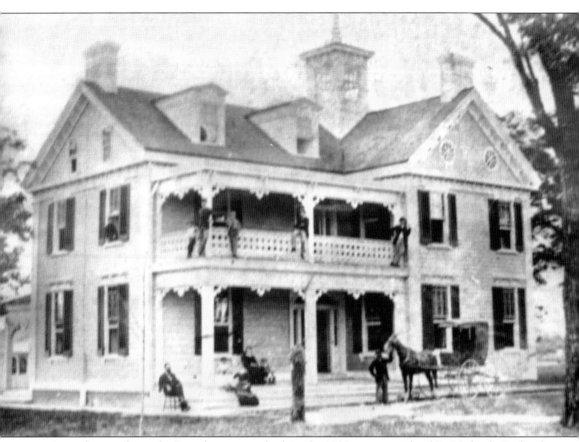

An early view shows the Beverly mansion, built in the 1880s, just outside of St. Michaels. Richard Spencer was owner of Beverly and was also a shipbuilder in town. Today the double porch and cupola are gone, but in their day, they were much enjoyed, as can be seen by the children hanging off the porch. (Courtesy of the Talbot County Free Library.)

ON THE COVER: Snow is a rare sight in wintertime on the Eastern Shore. A young man is taking advantage of the snowfall with a makeshift sleigh on Talbot Street in St. Michaels as his mother watches from the back porch, c. 1906. (Courtesy of St. Michaels Museum at St. Mary Square.)

IMAGES
of America

Around
ST. MICHAELS

Christina Vitabile

ARCADIA
PUBLISHING

Published by Arcadia Publishing
Charleston SC, Chicago IL, Portsmouth NH, San Francisco CA

Printed in the United States of America

Library of Congress Catalog Card Number: 2006920059

For all general information contact Arcadia Publishing at:
Telephone 843-853-2070
Fax 843-853-0044
E-mail sales@arcadiapublishing.com
For customer service and orders:
Toll-Free 1-888-313-2665

Visit us on the Internet at www.arcadiapublishing.com

To my parents, Al and Mary Ann, who loved the Eastern Shore and made sure their daughters appreciated its history as well as its beauty.

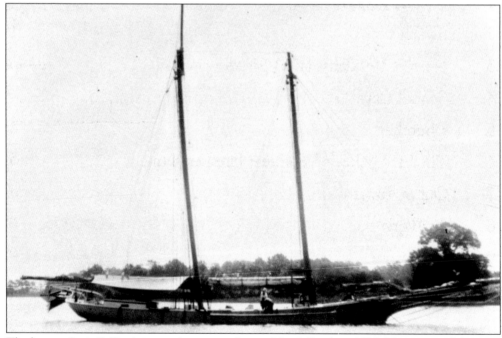

The bugeye *Susie E. Parris* is seen here at anchor in Island Creek in 1905. The origin of the term "bugeye" is still up for debate, but most likely, it derives from the Scotch settlers in the area whose term for oyster was "buckie." At one time, the boats also sported black dots on the bowsprit, so "bug's eye" may also be an explanation. (Courtesy of the Talbot County Free Library.)

CONTENTS

ACKNOWLEDGMENTS

Without the kind assistance of many people, this book would not be possible; herewith is a list of those with a love of local history and the dedication to its preservation, with a hearty thank you: Jackie Teeling, former president of the St. Mary's Square Museum, and her husband, Raymond, for infinite assistance and cups of tea; Beth Hansen, exemplary curator of the Talbot County Historical Society; Monique Gordy, curator of the Maryland Room at the Talbot County Free Library; Frank Henkel and Doug Haddaway of the St. Michaels Volunteer Fire Company, who took the time to talk with me and share photographs; Bob Shockley, who also spent an afternoon sharing family photographs and stories; Bonnie Messick, who generously loaned the postcard of the train station; Rosemary Fasolo and Jeremy Taylor at Pixels Post and Print, who did an excellent job scanning many of these photographs; Mary Ann Vitabile for jogging my memory of how it was; Nicole Vitabile for her fine collection of books on Eastern Shore history; Bob Kalish for encouragement; Tom Norton for technical assistance; and Lauren Bobier for her fine editorial input.

WORKS CITED

Brewington, M. V. *Chesapeake Bay Log Canoes and Bugeyes.* Cambridge, MD: Cornell Maritime Press, 1963.

Footner, Hulbert. *The Rivers of the Eastern Shore.* Cambridge, MD: Tidewater Publishers, 1944.

Graham, John L., ed. *The 1877 Atlases and Other Early Maps of the Eastern Shore of Maryland.* Salisbury, MD: Wicomico Bicentennial Commission, 1976.

Harper, Anna Ellis. *History of St. Michael's Parish.* St. Michaels, MD: Self-published, 1956.

Holly, David C. *Tidewater by Steamboat: A Saga of the Chesapeake.* Baltimore: Johns Hopkins University Press, 1991.

Hughes, Elizabeth. *Historic St. Michaels.* St. Michaels, MD: Historic St. Michaels–Bay Hundred, Inc., 1996.

Preston, Dickson J. *Talbot County: A History.* Centreville, MD: Tidewater Publishers, 1983.

———. *Young Frederick Douglass: The Maryland Years.* Baltimore: Johns Hopkins University Press, 1980.

Tilghman, Oswald, comp. *History of Talbot County, Maryland 1661–1861.* Baltimore: Regional Publishing Company, 1967.

Walsh, Harry M. *The Outlaw Gunner.* Cambridge, MD: Tidewater Publishers, 1971.

Weeks, Christopher. *Where Land and Water Intertwine.* Baltimore: Johns Hopkins University Press and the Maryland Historical Trust, 1984.

Wennersten, John R. *Maryland's Eastern Shore: A Journey in Time and Place.* Centreville, MD: Tidewater Publishers, 1992.

INTRODUCTION

The area that encompasses St. Michaels starts near Easton, at the head of the Miles River, a strip of land extending between the Miles and the Tred Avon Rivers. It runs westward to where the Miles River empties into Eastern Bay, ultimately connecting with the Chesapeake Bay. The Chesapeake Bay had many Italian and Spanish explorers and French fur traders prior to Capt. John Smith's first sight of the land in 1608. The area was noted for its vast acreage of timber and countless waterfowl and deer. The inhabitants of the area have always derived their livelihoods from the water—fishing for the most part—and subsistence farming. This was later followed by the cultivation of tobacco as a cash crop and shipbuilding to accommodate the trade. Once the land was settled, the primary export business was tobacco, lumber, and grain. The import goods included rum, sugar, and slaves. Some of the more exotic place names come from the areas of trade: Mount Misery, Jamaica Point, and San Domingo were all derived from the places along trade routes.

James Braddock was responsible for surveying his land and laying out town lots in 1778 around what was then a small cluster of houses. He was the agent for Messrs. Gildart and Gawith out of Liverpool and hoped to profit from having settlers come and work producing goods for shipment to England. The first residents in the area were, of course, Native Americans, and their place names were gradually changed as more Scottish, Irish, and English immigrants settled on what had been their tribal lands. The native peoples were gradually forced northward by this, settling mostly with the Iroquois nation in upstate New York. St. Michaels was the name given to the town and the river because the rents were due to Lord Baltimore on Michaelmas Day. The river's name was later shortened to Miles.

The population of the town included slaves as well as a sizeable population of free blacks, Native Americans, and transplants from the West Indies. The town was described as a rowdy one, in keeping with a port town where sailors would come in looking for a little excitement. They found it in town, where there were saloons and working-class townsfolk ready to do business with them. Fights were common; areas in town acquired names such as Hell's Crossing. Larger farms were almost small towns unto themselves—self-sufficient with tenant houses, barns, windmills, and sometimes sawmills and packinghouses. A large manor house would face the water, since trade was by the river. Land-owning families worked their indentured servants and slaves and built their business and fortunes from the imported labor force. The small tidewater homes became grand river mansions and plantations reflecting the new wealth from trade and farming.

Shipbuilding became the main industry in town, supplying Baltimore with the famous clippers and other freight ships. The log canoe design was borrowed from the Native Americans and modified for increased cargo hold and bay sailing. With shipbuilding came new innovations in the fishing industries, and St. Michaels was poised to become a major supplier of boats, tobacco, timber, and perishable goods. But the supply of good lumber was exhausted by the 1800s, tobacco exhausted the soil, and finally the oyster beds began to show signs of over-harvesting by the mid-1800s. Then, of course, the difficulties of keeping together a nation whose inhabitants wanted

both slavery and union were to turn the tide in the economic upswing. St. Michaels had a resident at this time who was to inaugurate the beginnings of civil rights for all men in the form of an unruly teenager named Fred Bailey. Fred changed his name to Frederick Douglass after his escape from the Auld family, and it was a result of his unhappy experience at the hands of slave breaker Edward Covey in St. Michaels that he realized his determination to escape and help other slaves do so as well.

St. Michaels did not see any battles during the Civil War, only the occasional Union troop coming through to make their presence known. While the town itself was pro-Union, taking its lead from Samuel Hambleton, war veteran of 1812, the rest of the county was pro-slavery. After the Civil War, the families struggled to hold onto their large tracts of land, but this was the period where farms were broken up and sold off to pay debts and to conserve resources. Many freed slaves moved north to the cities; the ones who remained established small enclaves such as Unionville and Bellevue and tried to find paying work where they could. Many became watermen as well, some owning their own packinghouses, trying to forge ahead in what was still a segregated society.

A series of economic depressions and decline in demand for goods overseas contributed to a less prosperous and therefore quieter life for residents in the area. The farms settled into wheat, corn, and tomato production. The watermen still worked the waters for local trade and for shipping to the western shore. The advent of steamship travel in the early 1800s heralded the start of tourism to the shore. Once the rail line was built after the Civil War, the influx of vacationers brought the area back to economic prosperity. Steamships and trains brought tourism to the area, bringing new business and revitalizing the towns along the waterways. In response to the tourism trade, farmers opened their family estates to boarders and welcomed the income brought by visitors to the Shore. The tourism declined after the steamships ceased regular travel in the 1930s and rail lines were discontinued by the late 1950s. The building of the Chesapeake Bay Bridge in 1952 opened the area up once again to visitors on their way to the beaches and en route to discovering small towns that had not changed much in the last 100 years. Today the area is still focused on tourism, fishing, and farming, but as the farms are divided into lots for luxury homes and the boat slips are being filled by more pleasure craft than workboats, the residents face a new future and strive to maintain their life and customs from a 400-year history of working on and by the water.

One

A CHANGING LANDSCAPE

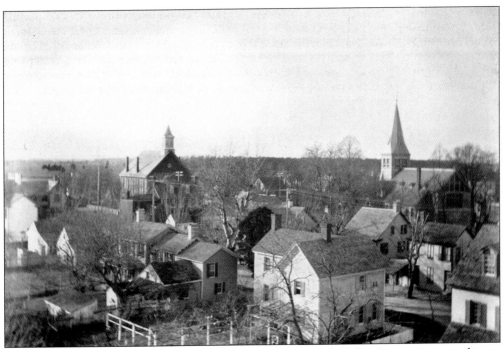

A rare aerial view of St. Michaels *c.* 1900 looking south towards Talbot Street gives us a glimpse of a sleepy river town dominated by churches. One can see the steeples of both St. Luke's United Methodist Church on the left and Christ Episcopal Church to the right. Talbot Street, the main thoroughfare through town, runs between the two churches. (Courtesy of the St. Michaels Museum at St. Mary's Square.)

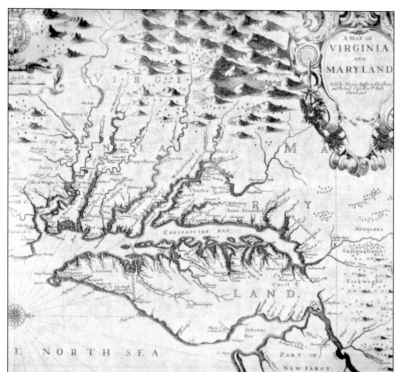

This is a map of Maryland and Virginia sold in England in the 18th century. At this time, the place names were primarily of Native American origin, with the exception of the trading ports. The major ports at this time included St. Michaels, Oxford, Annapolis, and Baltimore. (*The 1877 Atlases and Other Maps of the Eastern Shore of Maryland.*)

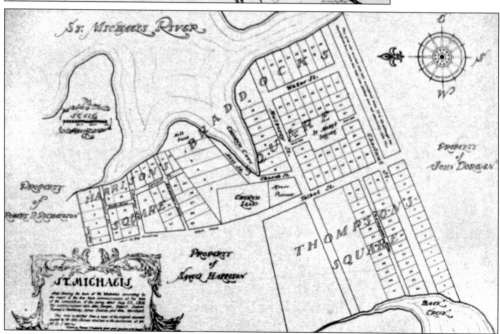

St. Michaels is the oldest town in Talbot County, with a rich trading and shipbuilding history dating from the 1630s. Originally the land was purchased by James Braddock to encourage workers to settle in the area and support the tobacco and shipbuilding industries. This is an 1806 map of St. Michaels, with the town lots as originally platted. (Courtesy of the St. Michaels Museum at St. Mary's Square.)

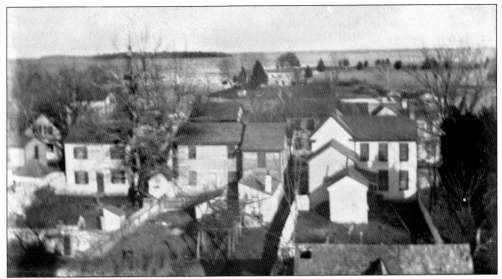

West of town, one travels toward Bozman, Neavitt, Claiborne, and Tilghman Island. East of town, one travels past Newcomb and Royal Oak to arrive at Easton. This is an eastward view of St. Michaels as it appeared in the late 1900s. (Courtesy of the St. Michaels Museum at St. Mary's Square.)

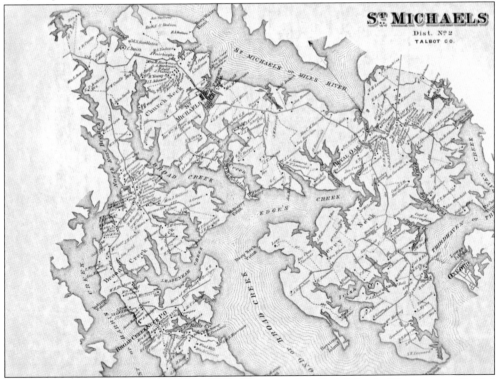

This map from 1877 encompasses the entire area surrounding St. Michaels. The area was divided into large farms, most of which are still in existence. The points of land ending at the water or at the heads of deep creeks were convenient places to load and unload tobacco, lumber, produce, and fish. (*The 1877 Atlases and Other Maps of the Eastern Shore of Maryland*.)

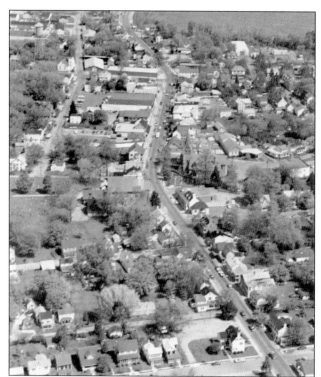

Looking westward over the town of St. Michaels in the 1970s, one can see a larger, more modern town that still retains its early Colonial planning. Steamers would arrive from the west via Claiborne Landing, bringing visitors, mail, and goods to town. (Courtesy of the St. Michaels Volunteer Fire Company.)

The Miles River was originally called the St. Michaels River in the 1700s. It is said that the Quakers objected to the name, and the shortened version stuck. The St. Michaels harbor, as seen in this aerial view, opens into the Miles River. The tourist trade, museums, and fine restaurants have replaced boatbuilding and seafood packing as major industries. (Courtesy of the St. Michaels Volunteer Fire Company.)

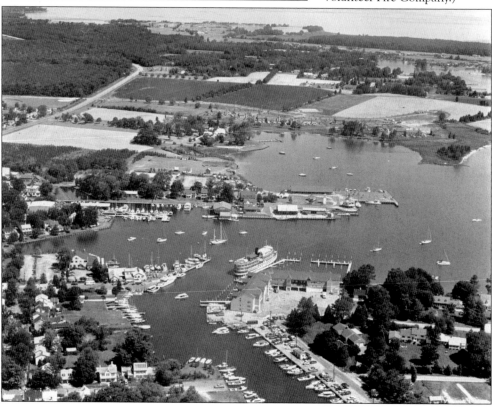

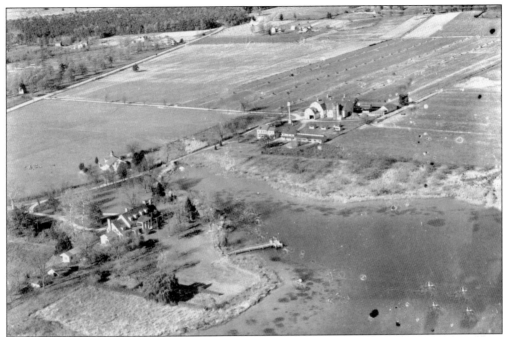

Perry Cabin farm was mostly open land, as it appears in this photograph from the 1970s. Originally a small farmhouse when purchased by Samuel Hambleton, it went through many additions and was still a working farm and riding academy in the early 1980s, when it was owned by Elsie Watkins Hunteman. Today it is run as a hotel complex and restaurant. (Courtesy of the Talbot County Free Library.)

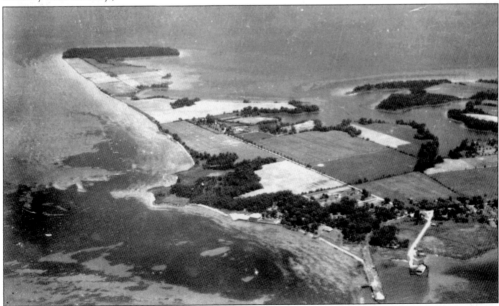

This is an aerial view of Rich Neck Farm, north of Claiborne, which was the first settled tract in Talbot County. It was conveyed to Capt. William Mitchell, who had promised Lord Calvert to bring settlers to the area. It was later the home of Matthew Tilghman Ward, a major general of the Colonial militia. (Courtesy of the Talbot County Free Library.)

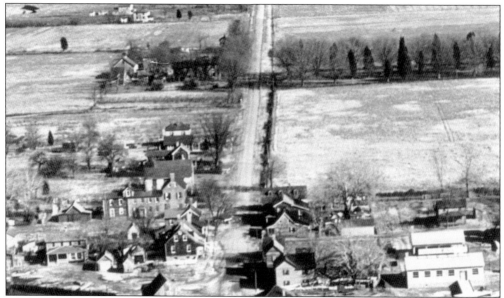

Claiborne Landing was the entry point for visitors from the western shore, as it has deep water and a strategic location for large boats. The town of Claiborne grew from the bustle of trade around this area, and there was a railway to meet the ships on arrival. Today only the remnants of the wharf remain, and the town is a sleepy village. (Courtesy of the Talbot County Free Library.)

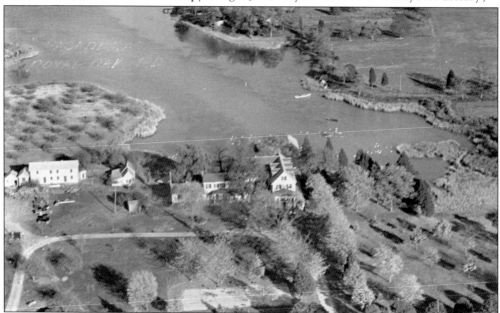

Royal Oak profited from being the halfway point on the rail line between St. Michaels and Easton, and as a result, a thriving village grew from tourism around the end of the 19th century. This is an aerial view of the Pasadena Inn, located in Royal Oak, several miles east of St. Michaels at the head of Oak Creek, which is a branch off the Miles River. It was originally an extensive farm, later turned into a hotel in the early 1900s. Fay Wray and Gary Cooper stayed here while filming *The First Kiss* in 1928. Today the house is still operated as a private hotel, and the original tenant houses still stand. (Courtesy of the Talbot County Free Library.)

Two

IN TOWN

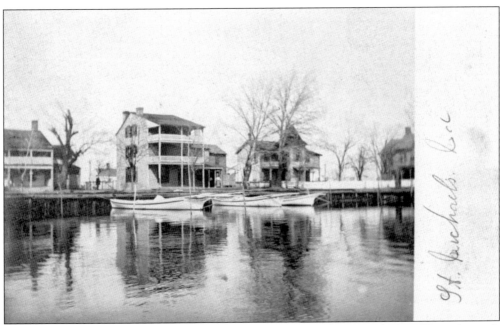

The original houses at Navy Point—the Higgins House (left), the Dyott-Dodson House (center), and the Eagle House—were built from the mid- to late 1800s on land originally owned by Samuel Hambleton of Perry Cabin. Farther east (to the right) would have been the canning and packinghouses, now part of the Maritime Museum complex. (Courtesy of the St. Michaels Museum at St. Mary's Square.)

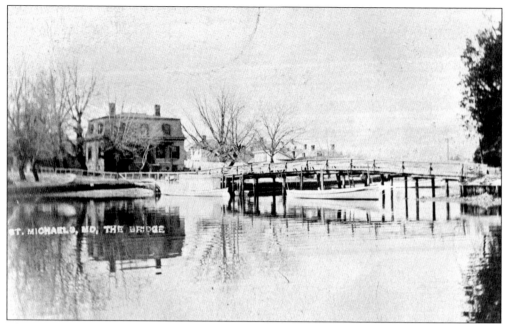

The footbridge that connected the town with Navy Point was known by several names: the Honeymoon Bridge, Sweetheart Bridge, and Lover's Bridge. The romantic walkway crosses the narrow cove off the harbor and joins Cherry Street to the south. The mansard-roofed house on the left is the Shannahan house, built by Henry Clay Dodson in 1873, now a bed and breakfast. (Courtesy of the St. Michaels Museum at St. Mary's Square.)

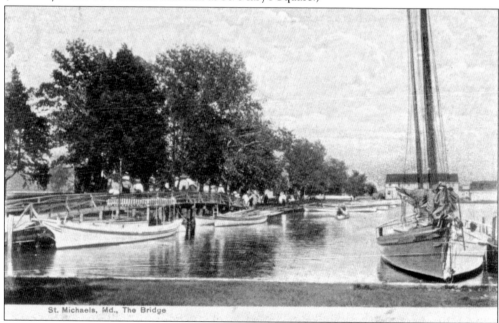

The Honeymoon Bridge is essentially unchanged since the 1900s. The building to the left behind the skipjack was an oyster packing plant; it is now the location of the Crab Claw Restaurant. Today tourists can still cross the bridge and admire the workboats as well as the sleek sailing and power vessels in the harbor. (Courtesy of the St. Michaels Museum at St. Mary's Square.)

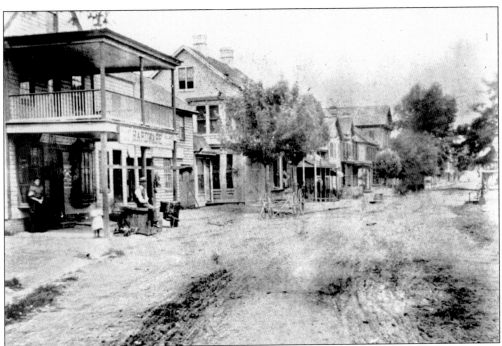

An early view of Talbot Street around the 1890s when it was still a dirt road leading through town shows many of the same buildings one can see today. The double porches on many of the buildings provided shade and allowed cooler air to circulate through the houses during the humid summer months. (Courtesy of the St. Michaels Museum at St. Mary's Square.)

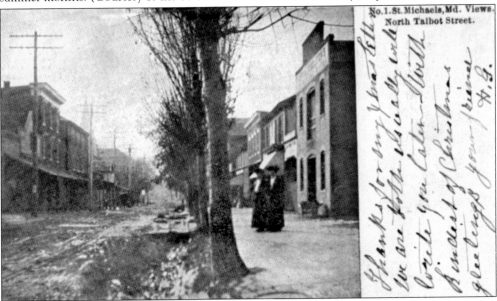

Through the 1800s, North Talbot Street in St. Michaels featured blacksmith shops, grocery and general merchandise stores, churches, carriage makers, a butcher, a tinner, and a few drinking establishments for the visiting sailors. It was known as a rowdy, bustling town that depended mainly on the business that came from the river. (Courtesy of the St. Michaels Museum at St. Mary's Square.)

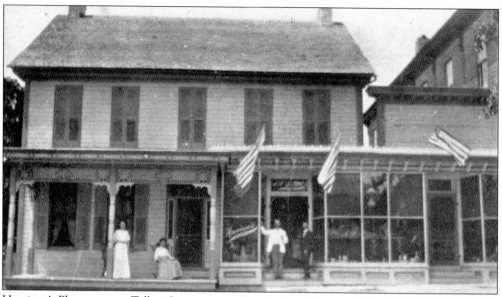

Harrison's Pharmacy on Talbot Street opened for business in the 1870s and was still operating until the early 1970s as a place where one could have a prescription filled, stop for lunch at the soda fountain, and pick up general merchandise. The original buildings still stand and are in use today as shops and restaurants. This photograph was taken in 1906. (Courtesy of the St. Michaels Museum at St. Mary's Square.)

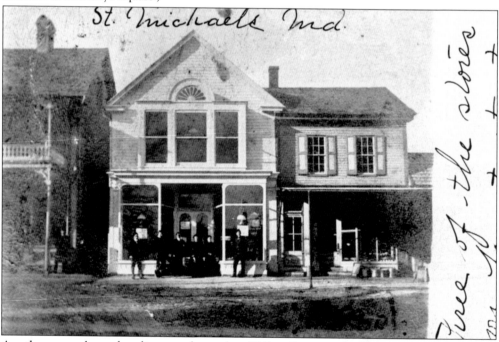

Another general merchandise store located on Talbot Street in the late 1800s gives a view of the economics of rural towns. Stores at this time carried a variety of items, not just food. One description of such a store's offerings included medicines, fine toilet soaps, brushes, trusses, wine, paints, varnish, pens, ink, letter paper, glass, putty, garden seeds, and lamps. (Courtesy of the St. Michaels Museum at St. Mary's Square.)

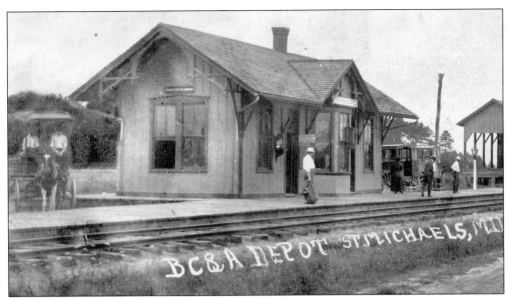

The St. Michaels Train station was in use until the early 1960s, when the trains stopped running and the station was relocated and turned into a private residence. For almost 100 years, this was the main depot for transportation and conveyance of goods to and from the town. (Collection of Bonnie Messick.)

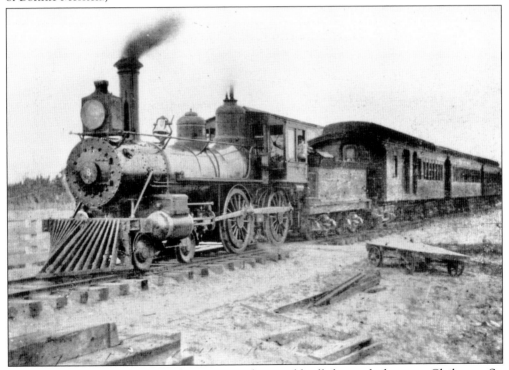

This is an example of the type of steam train that would roll the tracks between Claiborne, St. Michaels, and Easton. Train travel ran from Claiborne to the ocean, and the town stops along the way generated income for the local residents. The train heading east was called the *Ocean City Flyer*; traveling west it was the *Baltimore Flyer*. (Courtesy of the Talbot County Historical Society.)

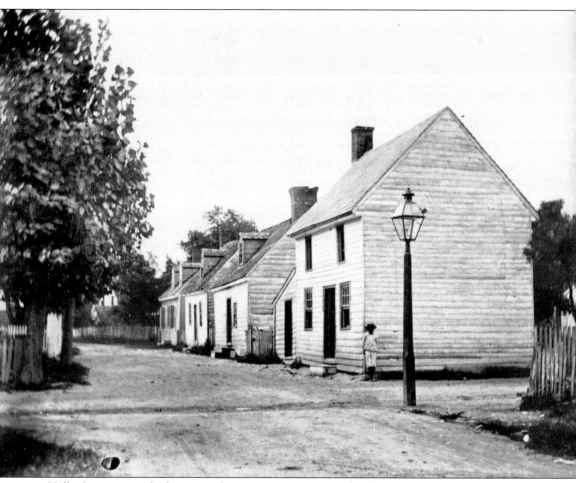

Hell's Crossing is today known as the intersection in St. Michaels of Carpenter and Locust Streets. Many of the town's African and West Indian descendants lived here and worked in the shipyards. The name refers to the proximity of the intersection to the harbor, where visiting sailors would disembark and visit the local saloons till the wee hours before returning to ship. Legend has it that this was the sight of many a drunken brawl in the 1700s. (Courtesy of the Talbot County Historical Society.)

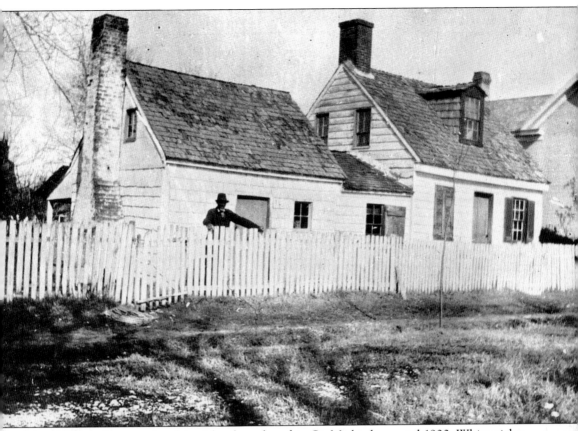

A gentleman leans against his picket-fenced yard in St. Michaels around 1900. White picket fences of this type can still be seen in town as a reminder of life as it was 100 years ago. Some of the oldest surviving structures in town are located in this area of town in the block surrounding St. Mary's Square. (Courtesy of the Talbot County Historical Society.)

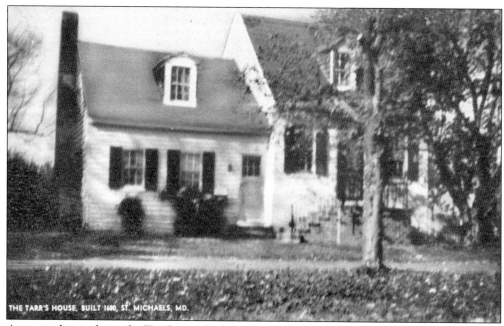

THE TARR'S HOUSE, BUILT 1600, ST. MICHAELS, MD.

A postcard view shows the Tarr house, built between 1800 and 1810 and located on Green Street facing the harbor. Originally the town was divided into narrow city lots and advertised for sale through the efforts of James Braddock, who was an agent for the Liverpool firm of Messrs. Kildart and John Gawith, exporting goods such as tobacco, grain, and lumber. (Author's collection.)

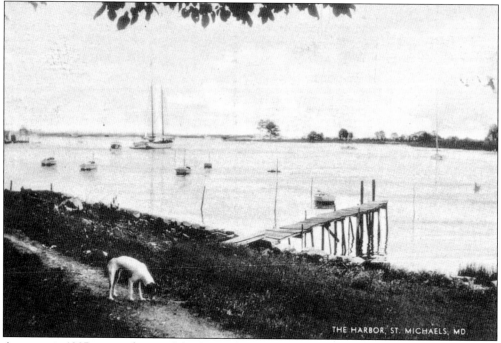

THE HARBOR, ST. MICHAELS, MD.

A romantic 1907 postcard view of the St. Michaels Harbor shows a dog in the foreground, a view not unlike one today, where one can see the residents walking their dogs through town on busy weekends. (Courtesy of the St. Michaels Museum at St. Mary's Square.)

22

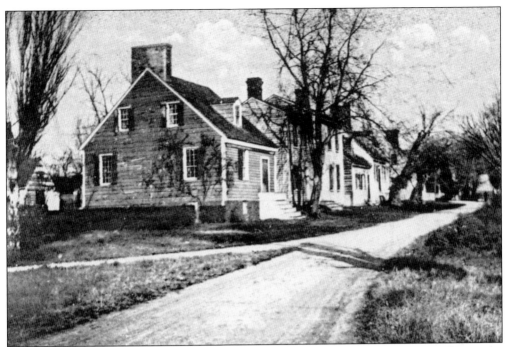

In this photograph of houses along Green Street Thoroughfare in 1906, one can make out the oyster-shell road in front of the picket fence. Prior to macadam, oyster shells, being plentiful, were used extensively on the roads throughout Talbot County. (Courtesy of the St. Michaels Museum at St. Mary's Square.)

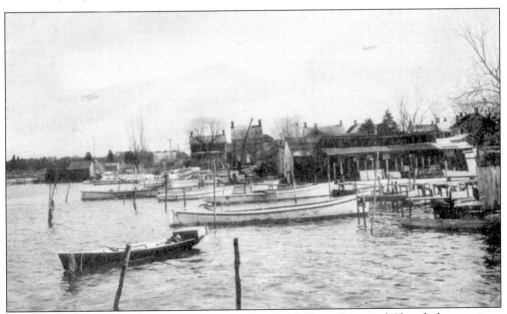

This 1910 postcard view of Church Cove Harbor behind Christ Episcopal Church demonstrates the working-class atmosphere that defined the town at the turn of the 20th century. Today these pictures seem quaint, but families depended on the river not only for food but also for transportation and their livelihood. (Courtesy of the St. Michaels Museum at St. Mary's Square.)

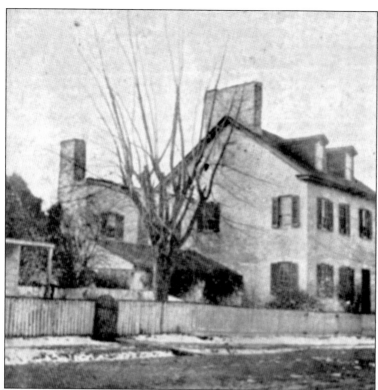

The Cannonball House was built by William Merchant, who was a ship builder in town. The house has an amusing history as the only house in St. Michaels to be hit by British cannon fire during the 1813 attack. A cannonball penetrated the dormer window and rolled down the stairs, and legend has it that the mistress of the house had to step to the side with her child to avoid the ball's path. (Courtesy of the St. Michaels Museum at St. Mary's Square.)

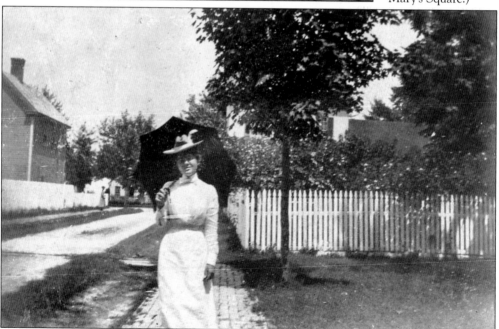

Alice Mowbray can be seen here taking a stroll in town around 1907. Parasols were the only sunscreen available to protect from the summer sun at the beginning of the 20th century. It was considered improper for ladies to have a tan and freckles, which is why they wore high-necked, long-sleeved dresses in the heat. (Courtesy of the St. Michaels Museum at St. Mary's Square.)

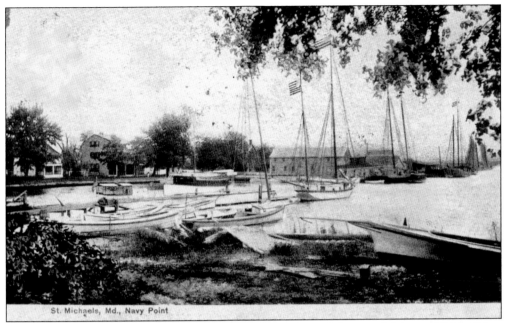

St. Michaels, Md., Navy Point

The St. Michaels harbor was a noisy, rough area for most of the town's history. Shipbuilders were located at the end of every street, sailors would come into town looking for a saloon, and in general, the town had a reputation for high spirits and rowdy fighting. This is a postcard view from 1906 that shows the working skiffs and skipjacks in the harbor. (Courtesy of the St. Michaels Museum at St. Mary's Square.)

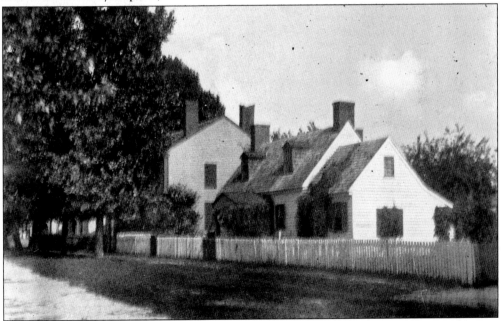

One of the oldest houses extant in St. Michaels is also the birthplace of Amelia Coppuck Welby, writer of flowery Victorian prose. The house was originally built in the late 1700s and owned by Capt. Philip Wetheral, who operated a shipyard and blacksmith shop. The house is located on Mulberry Street. (Courtesy of the St. Michaels Museum at St. Mary's Square.)

Dr. Dodson's house on Cherry Street was also the site of the first post office in town. Dr. R. A. Dodson was listed in the town records in the late 1800s as being both a physician and surgeon. (Courtesy of the St. Michaels Museum at St. Mary's Square.)

Dr. Dodson's house, as seen today, still retains its old brick double-porch, double-chimney Colonial facade. It is located at the corner of Cherry and Locust Streets a block from the harbor. (Author's collection.)

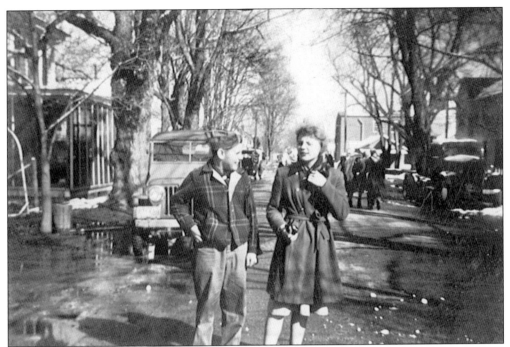

Jimmy Sewell and Marion Wallach are seen here smiling on a chilly day on Chew Avenue around 1950. (Courtesy of Robert Shockley.)

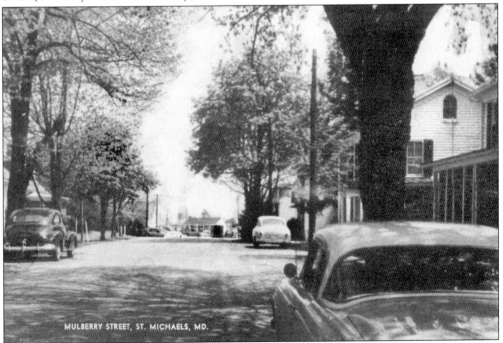

MULBERRY STREET, ST. MICHAELS, MD.

Mulberry Street runs east and west in town; this is the view looking east toward the harbor around 1950. This part of Mulberry borders the north side of St. Mary's Square and still features some of the loveliest vernacular architecture on the Eastern Shore. (Courtesy of the St. Michaels Museum at St. Mary's Square.)

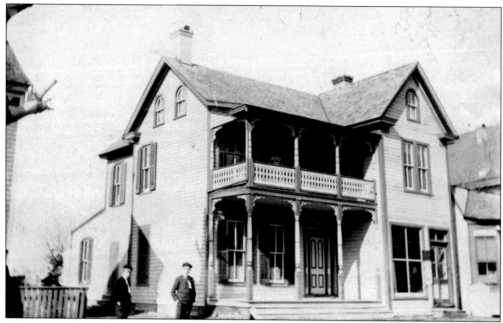

A fine example of the ornate gingerbread Queen Anne architecture that can be seen in town is located on Talbot Street. This is the Mary Morris house, pictured c. 1900, located at the corner of West Chew Avenue and South Talbot Street. There was a store entrance on the right side, where the owner ran a business, and the porch entrance was for the family. (Courtesy of the St. Michaels Museum at St. Mary's Square.)

The old St. Michaels Bank, shown around 1900, was located on the corner of Talbot and Willow Streets. The bank now occupies a former residence in town on Talbot Street. (Courtesy of the St. Michaels Museum at St. Mary's Square.)

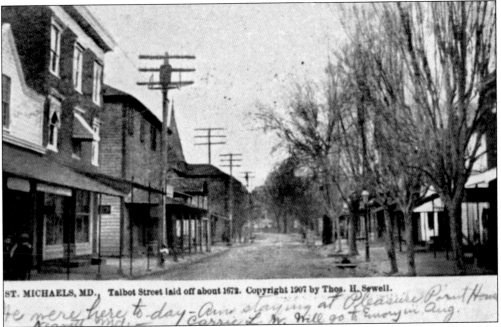

we were here to-day—Ann staying at Pleasure Point Hous Carrie L. W. Will go to Emory in Aug.

In this view of Talbot Street looking south in 1907, the effects of modernity are visible in the telegraph wires along the skyline. In the distance to the left can be seen the steeple of Christ Episcopal Church. (Courtesy of the St. Michaels Museum at St. Mary's Square.)

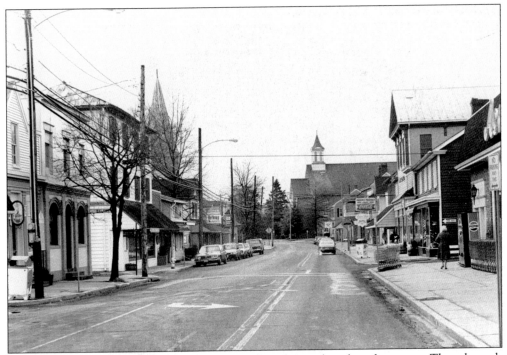

The same view of Talbot Street in the 1970s is less cluttered, with wider streets. The telegraph poles are replaced by telephone poles, and most of the trees have been removed. (Courtesy of the St. Michaels Museum at St. Mary's Square.)

The museum building at St. Mary's Square is a typical Tidewater telescope house from 1865, which now serves as the museum headquarters. The square on which it is located is part of the original plan of James Braddock, who laid out the town lots. (Author's collection.)

The St. Michaels Museum at the St. Mary's Square complex features several original structures that have been relocated to the square from around the town. The complex is the former site of the St. Michaels High School. (Author's collection.)

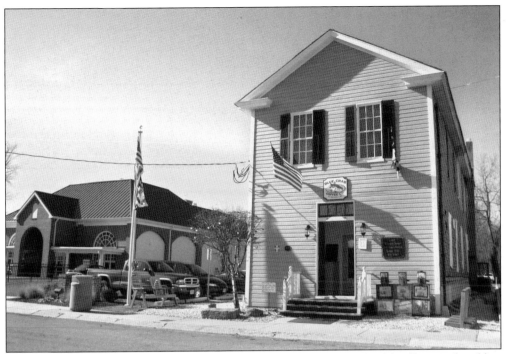

Freedom's Friend Lodge Number 1024 of the Grand United Order of Odd Fellows is the oldest black lodge building in the state, built in 1883. It was restored and now serves as a café. The building next door is the St. Michaels Branch Library, built in 1988. (Author's collection.)

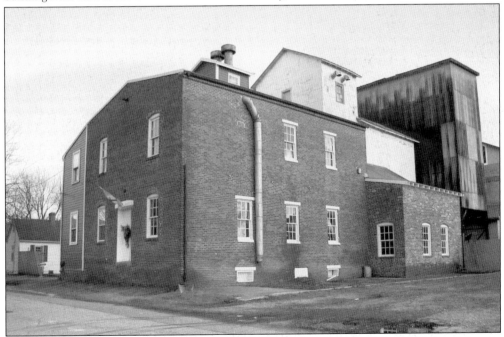

The St. Michaels Flour Mill manufactured foodstuffs for Bayshore Foods before it closed shop in the late 1970s. It milled and packaged under the name Just Right Flour. Built in 1890 on Chew Avenue and fronting on Talbot Street, the mill complex is still intact. (Author's collection.)

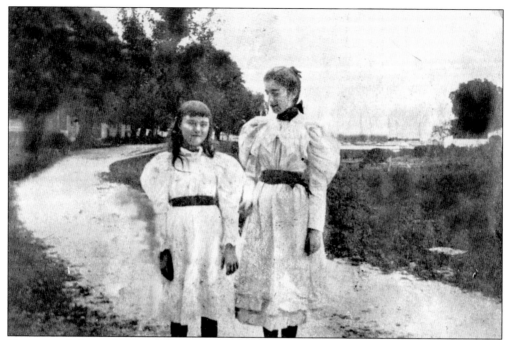

Two young ladies in 1906 pose in their Sunday clothes on the Green Street Thoroughfare when it was an oyster-shell road fronting Muskrat Park behind Christ Episcopal Church. Today the park offers a gazebo and benches and a landscaped area to welcome visitors. (Courtesy of the St. Michaels Museum at St. Mary's Square.)

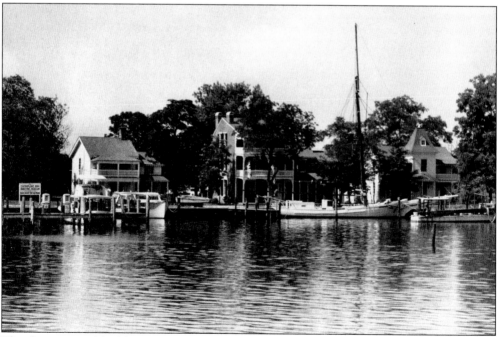

The three original buildings on Cherry Street at Navy Point, which front the harbor, are now part of the St. Michaels Maritime Museum. The skipjack moored to the right is one of only 19 left in existence on the bay. (Courtesy of the St. Michaels Museum at St. Mary's Square.)

Three

NOTABLE RESIDENTS AND VISITORS

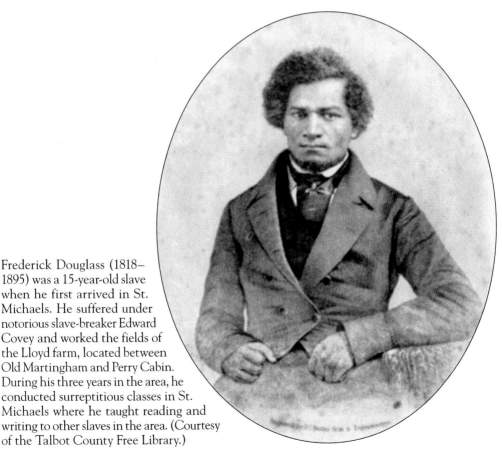

Frederick Douglass (1818–1895) was a 15-year-old slave when he first arrived in St. Michaels. He suffered under notorious slave-breaker Edward Covey and worked the fields of the Lloyd farm, located between Old Martingham and Perry Cabin. During his three years in the area, he conducted surreptitious classes in St. Michaels where he taught reading and writing to other slaves in the area. (Courtesy of the Talbot County Free Library.)

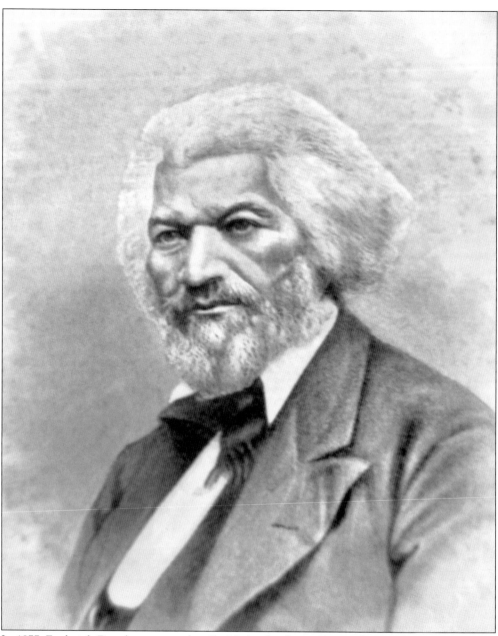

In 1877, Frederick Douglass returned to St. Michaels after a 41-year absence for a brief meeting with his old master Thomas Auld; it was reported that they parted amiably. Douglass briefly entertained the idea of spending his last years on an estate in or near St. Michaels and made a third trip to the area in 1893. The idea never transpired, and it was the last visit Douglass made to the area. (Courtesy of the Talbot County Free Library.)

Poet laureate of Maryland Amelia Coppuck Welby (1819–1852) is depicted here in an engraving frontispiece. This is one of the few likenesses of the woman that Edgar Allan Poe praised in a critique of her poetry in the mid-1800s. She was born in St. Michaels, and at seven years of age, her family relocated to Kentucky to find their fortune. She died leaving a few vivid poems that perhaps recall some memories of her early years in the area. (Courtesy of the Talbot County Free Library.)

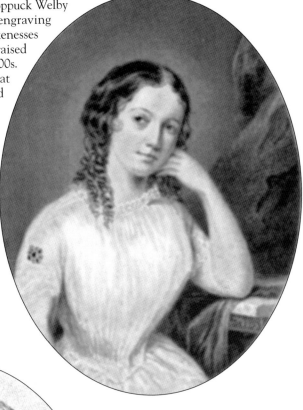

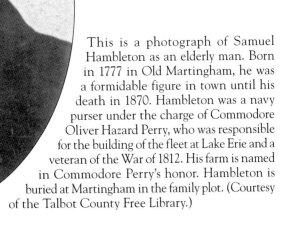

This is a photograph of Samuel Hambleton as an elderly man. Born in 1777 in Old Martingham, he was a formidable figure in town until his death in 1870. Hambleton was a navy purser under the charge of Commodore Oliver Hazard Perry, who was responsible for the building of the fleet at Lake Erie and a veteran of the War of 1812. His farm is named in Commodore Perry's honor. Hambleton is buried at Martingham in the family plot. (Courtesy of the Talbot County Free Library.)

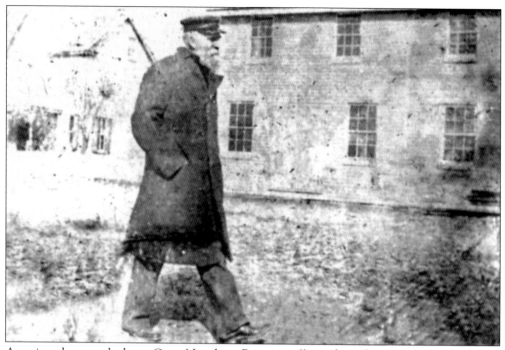

A grainy photograph shows Capt. Napoleon Benson walking through town in the late 1800s. The Benson family was well-known in the area, with their descendants working on the bay and its tributaries. To captain one's own skipjack indicated a measure of prestige, as these men were a combination of merchant, employer, and navigator. (Courtesy of the St. Michaels Museum at St. Mary's Square.)

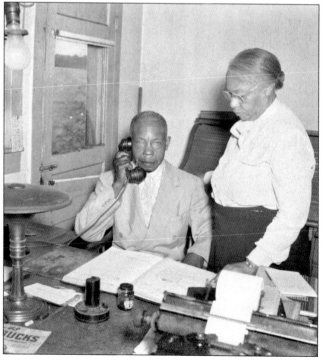

Mr. and Mrs. Frederick S. Jewett are seen posing in their office at the Coulbourne and Jewett Seafood Packing Company. Frederick Jewett was one of the most successful African American business owners of the early 20th century. Along with partners H. T. Coulbourne and the Reverend Charles Downes, he established the packinghouse in 1902 and is remembered chiefly for his business acumen, integrity, and for devising the crabmeat grading system that is still used nationwide today. Legend has it that locals preferred to do business with Jewett as he was one of the most honest businessmen in the area. (Courtesy of the Talbot County Historical Society.)

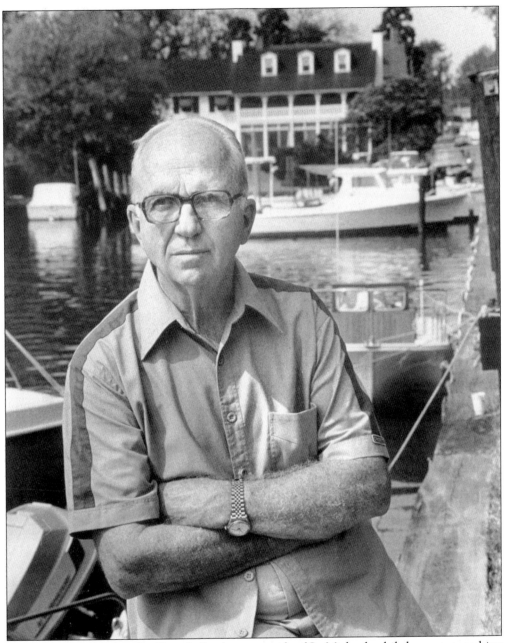

James Michener lived in the Church Creek area outside of St. Michaels while he was researching and writing his novel *Chesapeake*. During his time in the area in the late 1970s, he was a familiar sight around town with his wife, Mari Yoriko Sabusawa, gathering material for his book from the local residents and taking part in the social scene. Once the book was finished, he returned to his home in Bucks County, Pennsylvania. (Courtesy of the Talbot County Free Library.)

This is a c. 1928 publicity photograph of Fay Wray taking a break from filming the silent picture *First Kiss* with the Miles River in the distance. Fay ended her stay in St. Michaels by marrying her scriptwriter at the Talbot County Courthouse when filming was completed. She later went on to success in "talking" films and is forever remembered as the love interest of King Kong. (Courtesy of the Talbot County Historical Society.)

This is a film still of Fay Wray and Gary Cooper in *First Kiss* in 1928. There are only a few photographs of the film surviving; the movie has not been preserved. This shot was taken in the St. Michaels harbor. (Courtesy of the Talbot County Historical Society.)

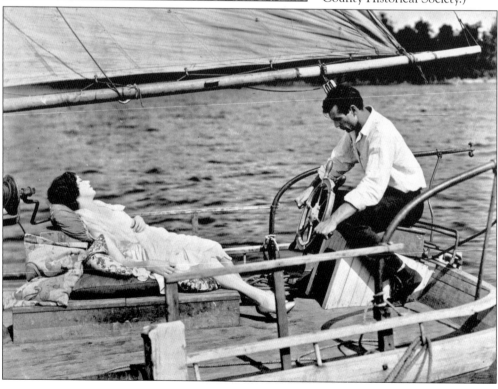

Four

SCHOOL DAYS

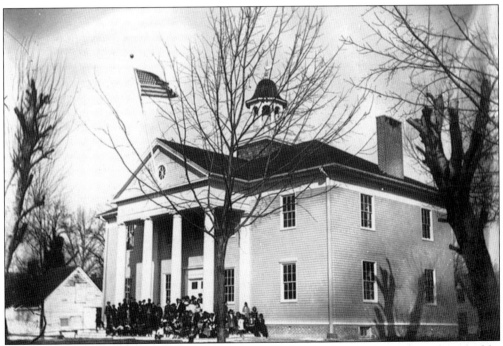

This was the first high school for students in the St. Michaels area; it was later destroyed by fire in 1920. It was located where the St. Michaels Museum at St. Mary's Square is now located. (Courtesy of the St. Michaels Museum at St. Mary's Square.)

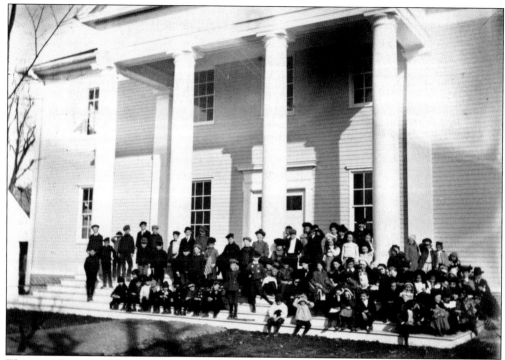

This is a close-up of the first school, with the entire student body gathered on the front steps. Schools at this time were segregated and offered education to the town and area children, most of whom would leave early to start their working life. (Courtesy of the St. Michaels Museum at St. Mary's Square.)

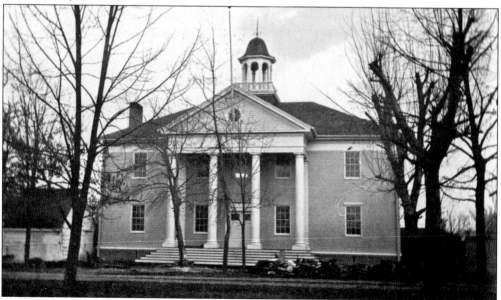

Here we see a front view of the first St. Michaels School, c. 1915. As late as 1950, the school offered classes only up until the 11th grade. Most graduates either went to work on the family farms or on the water while still in their teens. (Courtesy of the St. Michaels Museum at St. Mary's Square.)

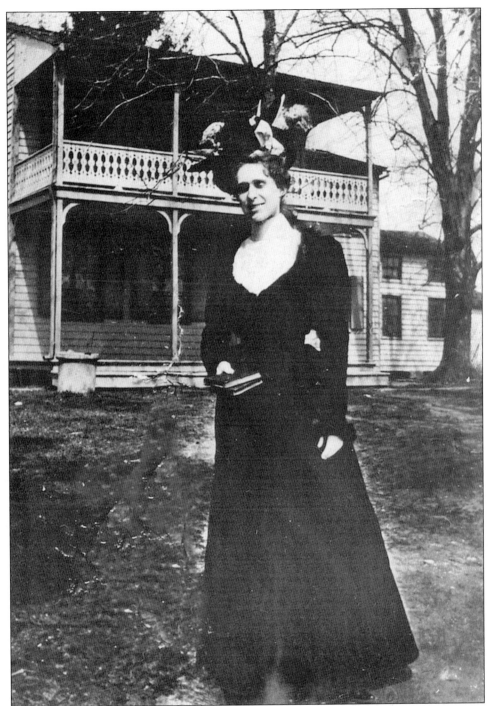

Of "Miss Annie" the art teacher we do not know too much other than that she lived and taught in town during the 1900s and made a striking figure. Schoolteachers were usually from the community and well educated; they understood the difficulties of making a living from the water and from farming and instructed their students well until they left to support their families. (Courtesy of the St. Michaels Museum at St. Mary's Square.)

The second St. Michaels School was built in 1899, this time of brick, and was razed in 1966 to make way for a larger building to accommodate the town's growing school-age population. (Courtesy of the Talbot County Free Library.)

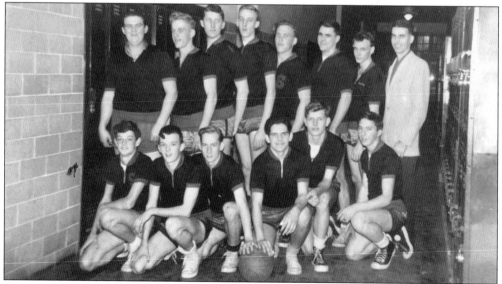

The townsfolk in St. Michaels have always been very supportive of their teams and players. This is a photograph of the St. Michaels High School basketball team in 1953, coached by Joe Smith. From left to right are (first row) Jackie Jump, Frank Wilson, Phil Langrell, Bernie Ames, Merton Jarboe, and Larry Leonard; (second row) Francis Hudson, Ed Kilmon, Bob Shockley, Jon Berry, Joe Kilmon, Townsend Parkinson, Ronnie Miles, and Joe Smith (in the jacket). (Courtesy of Robert Shockley.)

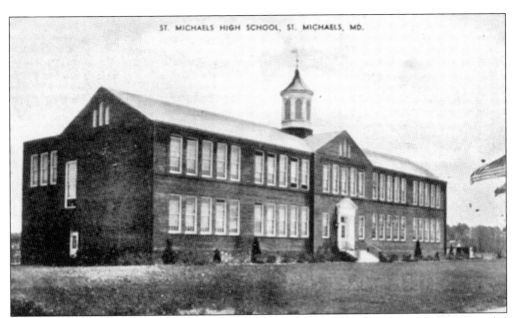

The third St Michaels High School was located just south of town on Route 33 and was also constructed of brick. It too met the wrecking ball in the 1980s to make room for the current school complex, which merged the elementary and formerly segregated black schools. Today there is a community pool where the old high school used to be. (Author's collection.)

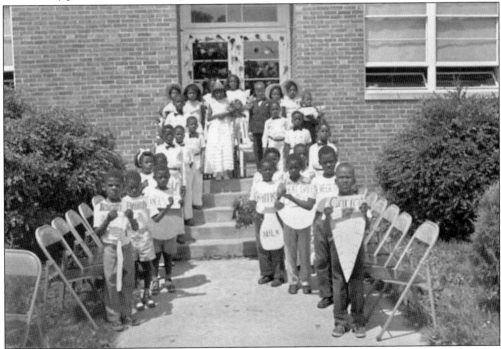

The Frederick Douglass School was located on the north side of town a block west of Talbot Street. It was the segregated school for black children and was desegregated in the late 1960s. This is a photograph before desegregation that shows some very proud schoolchildren demonstrating their project on nutrition in the 1950s. (Courtesy of the Talbot Historical Society.)

43

In the era of segregation, the Frederick Douglass School was the educational hub of the black community. This is a view on the west side of the building during the late 1950s. (Courtesy of the Talbot County Historical Society.)

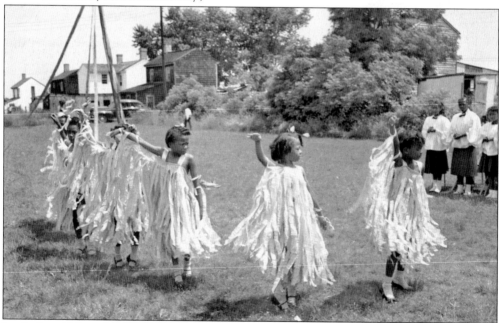

In the late 19th and early 20th centuries, maypole dances were a way for children to celebrate the coming of springtime and warmer weather. Not only are these children elaborately costumed, but they also seem to be enjoying their maypole dance c. 1960. (Courtesy of the Talbot Historical Society.)

Five

CHURCHES

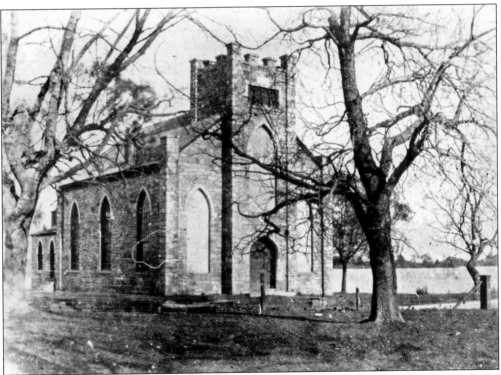

St. John's Chapel was consecrated in 1839 as a chapel of ease extending to congregants of the St. Michaels Parish. The original church on the site was named Dundee, also a chapel of ease that had fallen into disrepair by 1781. This was at the headwaters of the Miles River, the last stop on the steamer service from Baltimore, where passengers could disembark and take a carriage the remaining several miles to Easton. A bridge now crosses the river where a ferry once operated. (Courtesy of the St. Michaels Museum at St. Mary's Square.)

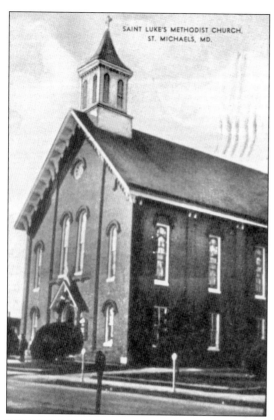

SAINT LUKE'S METHODIST CHURCH,
ST. MICHAELS, MD.

St. Luke's Methodist Church is located on Talbot Street in the center of St. Michaels. This postcard shows the original edifice before the addition in 1971. Methodism was introduced to the Delmarva Peninsula by Francis Asbury in 1772. Gambling, drunkenness, and horse racing were frowned upon. As popular as the Methodist church was, its parishioners must have been sorely tried since the pastor of Christ Episcopal Church across the street owned a racetrack that he operated after his services on Sundays. (Author's collection.)

St. Luke's Methodist Church dates from 1871 and has a sizeable cemetery to the rear of the property. Religion has always played a major social as well as spiritual role in the area; it was only during the Civil War that some breakaways occurred and Southern sympathizers organized their own chapels out of town. (Author's collection.)

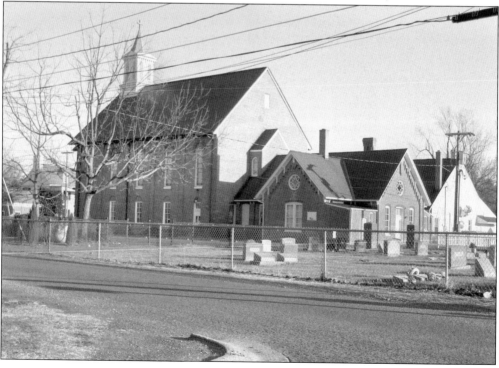

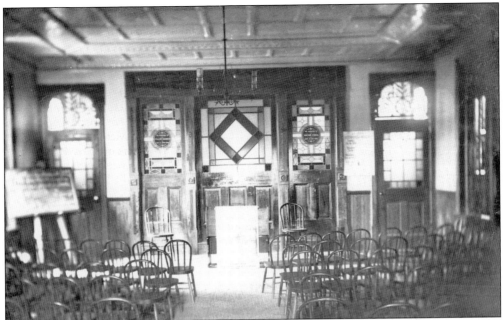

This is a photograph of the sanctuary of St. Luke's Methodist Church before the renovations in 1880. The townspeople have always been justifiably proud of their churches and strive to make improvements in keeping with the existing architecture to meet the needs of their congregations. (Courtesy of the St. Michaels Museum at St. Mary's Square.)

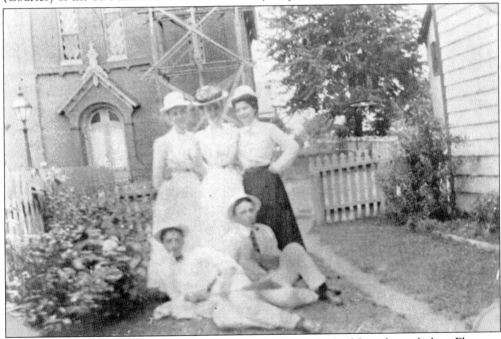

This photograph dates from around 1906 and shows a group of friends, including Florence Cunningham (far left) and Millie Dobson (far right). The St. Luke's Methodist Church is in the background and makes a nice backdrop for a gathering on a hazy summer day. (Courtesy of the St. Michaels Museum at St. Mary's Square.)

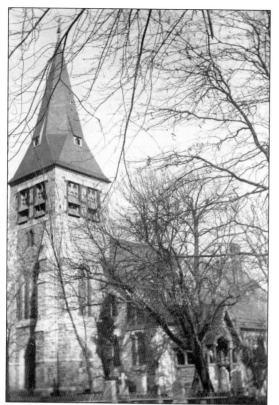

John Hollingsworth patented in 1664 fifty acres around the shore and named it "The Beach," where the first church was built. The present Christ Church was built in 1878, which was the fourth church to occupy the site. The porch at the south entrance is a memorial to its builder, Capt. Daniel Feddeman, whose remains are close by. The full name is the Christ Protestant Episcopal Church of St. Michael's Parish. (Courtesy of the St. Michaels Museum at St. Mary's Square.)

This young man dressed in his Sunday best sits on the iron gate at the Methodist Parsonage on Talbot Street, c. 1890. St. Michaels homes were usually surrounded by white picket fences, but a few home owners who could afford it used wrought iron. (Courtesy of the St. Michaels Museum at St. Mary's Square.)

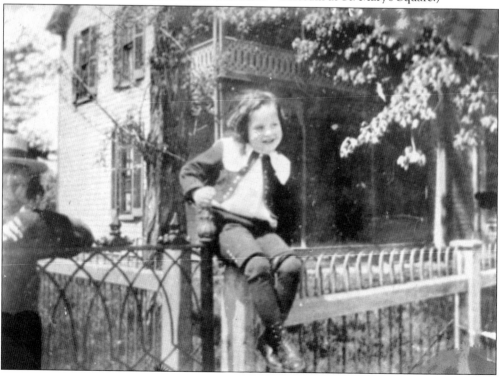

This view of Christ Episcopal from Church Cove gives the viewer an idea of what it was like to put in at the beach on Sunday and walk the 200 yards or so up to church for services. Christ Episcopal was a major seat in the parish; wealthier congregants would have servants row them into the cove. Churches in the area were traditionally built on the highest ground, mostly to avoid rising tides but also to serve as a reminder of the importance of the church as the spiritual center of the community. (Author's collection.)

This is the former Sardis Methodist Chapel, known as the Granite Lodge since 1871. When the present St. Luke's Church was constructed, the congregants relocated. The building dates from 1832, having replaced the first Methodist church erected on the site in 1782, which was the first Methodist church in Talbot County. In 1857, the building was in use as the St. Michaels Female Academy and is still located on St. Mary's Square. (Author's collection.)

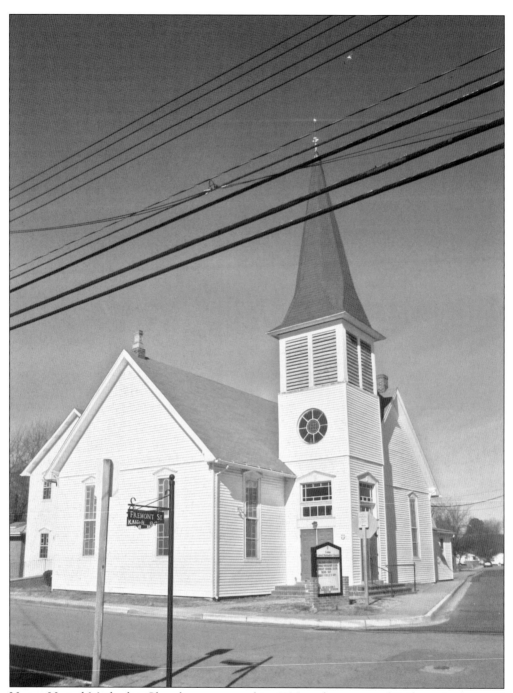

Union United Methodist Church, constructed in 1895 at the corner of Railway Avenue and Fremont Street, is the oldest African American church in St. Michaels. It was built by master craftsman Horace Turner, who also built many of the distinctive homes in town. The church is an imposing and distinctive presence in the town landscape. (Author's collection.)

The quaint Methodist chapel at Claiborne was built in 1912 to serve the townspeople as well as the summer tourists arriving from Baltimore via the nearby steamboat wharf. There is another chapel further up on Rich Neck Farm, believed to be the oldest in the county, but it is closed to the public. Claiborne's chapel, however, is still in service to townsfolk and visitors. (Author's collection.)

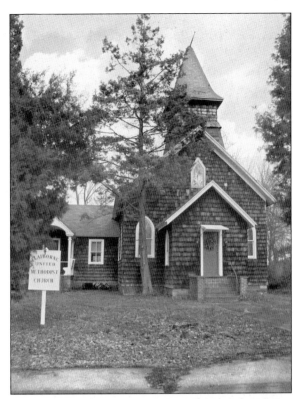

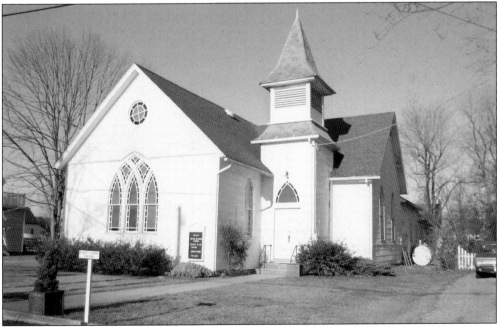

The white clapboard church is almost ubiquitous in the small towns on the Eastern Shore. Usually simple in design, with a modest bell tower and perhaps some colored glass, these structures are the focal points of the communities they serve. This lovely church from the late 1800s is located in Neavitt, a small waterman's community northwest of St. Michaels. (Author's collection.)

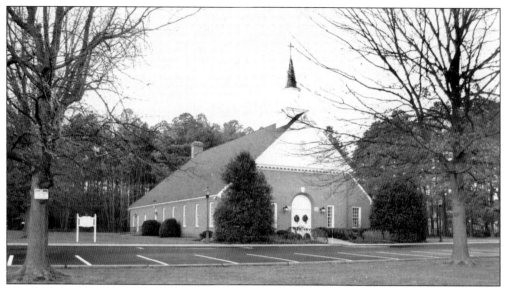

The Catholic Church of SS. Peter and Paul was built as a chapel of ease in 1968 to serve congregants in the St. Michaels area. Maryland was promoted as a colony that would give settlers the freedom to practice their faiths and was endorsed by Lord Baltimore. However, the Anglican Church becoming the state-endorsed religion in the 1690s and the subsequent popularity of Methodism 100 years later created tensions with the minority Quakers and Catholics in the area. (Author's collection.)

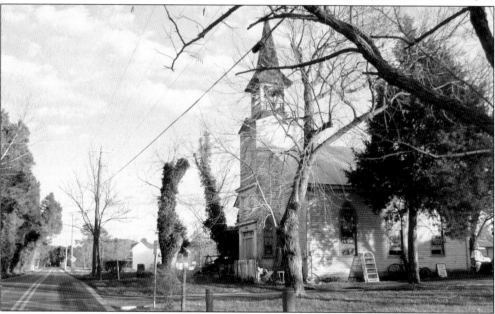

The chapel at Royal Oak was built in 1875 by Methodist who were still sympathetic to the cause of the Confederacy after the end of the Civil War. During the Civil War, Southern sympathizers refused to enter a church through the front doors if it meant walking under the Union flag; many would climb through the windows in protest in order to attend services. As a result, a number of breakaway churches such as this one were built. The Royal Oak Chapel has been in disuse since before the 1960s and is now being used as storage for an antiques shop across the street. (Author's collection.)

52

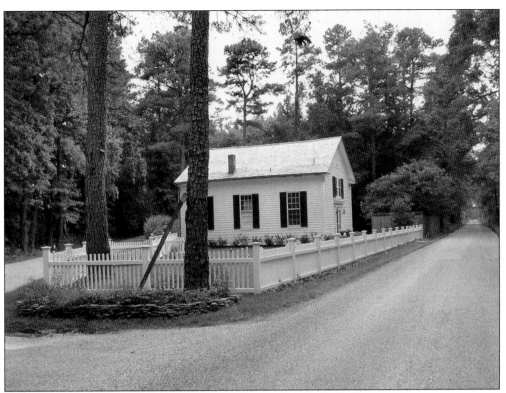

The Ferry Neck Chapel was established by E. L. F. Hardcastle of Plaindealing Farm in memory of her two little boys, who died tragically young. The date above the door reads "Anno Domini 1856." The chapel held occasional services performed by the rectors of Christ Church in St. Michaels until 1910. The chapel of ease is now a private residence and located just south of Bellevue outside of town. (Author's collection.)

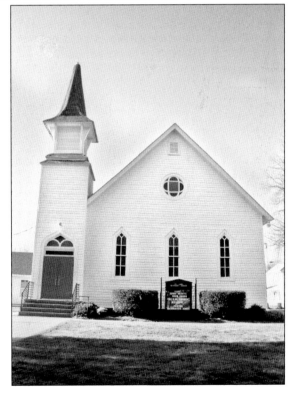

The United Methodist church in Bellevue, also known as St. Luke's, was built in 1886 to serve the spiritual needs of the black watermen and their families. Bellevue boasted several seafood packinghouses and sundry businesses, mostly owned and operated by the African American residents. (Author's collection.)

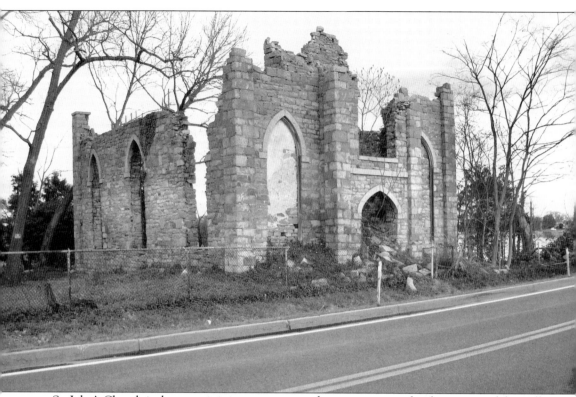

St. John's Church is shown as it is in recent times, the tower gone and only sections of the walls remaining. It is located about six miles from St. Michaels on the way to Tunis Mills. Almost from the beginning, the church's heavy granite construction began sinking into the soft soil near the water, and it had to be abandoned by 1900. The church still stands today, albeit in ruins, and is closed to visitors. (Author's collection.)

Six

THE ST. MICHAELS VOLUNTEER FIRE DEPARTMENT

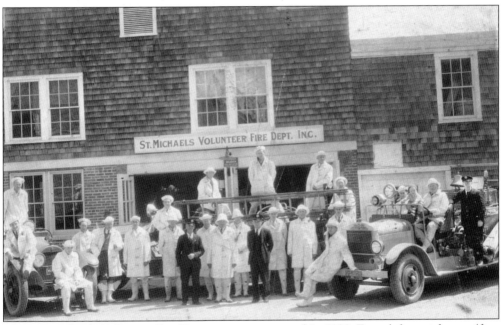

The St. Michaels Volunteer Fire Department is pictured in 1930. From left to right are (first row) Elmer Parkerson, Peck Granger, Roland Plummer, Ollie Larrimore, Tom Hudson, Albert Wales, Arthur Lewis, Joe Fairbank, Lee Swanhaus, Lee Fitzpatrick, Sam Radcliffe, Gene Rude, John Harper, Cecil Keithley, and Herbert Harrison; (second row, standing on the trucks) Oliver Lee, John Shockley, Filemon Lewis, Frank Jefferson, and Phil Hope; (on the REO Speedwagon bumper) Harrison Radcliffe; (seated in the Speedwagon) Mac Caplan, Peck Granger's son, and Bill Covington; (on the running board) George Todd. (Courtesy of the St. Michaels Fire Volunteer Department.)

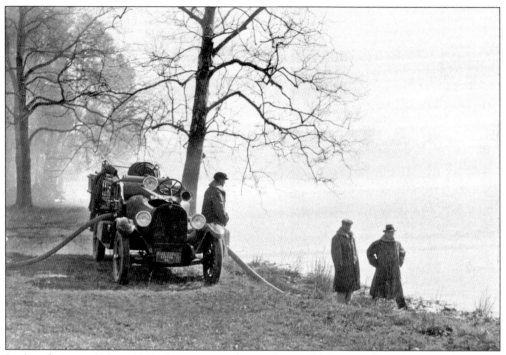

In this photograph from 1910, the pump truck uses the available water from the river. (Courtesy of the Talbot County Historical Society.)

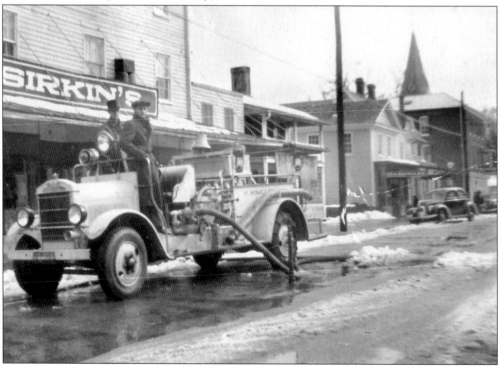

The fire truck sits in front of Sirkins' Store on Talbot Street c. 1930 after having battled a small blaze. (Courtesy of the St. Michaels Volunteer Fire Department.)

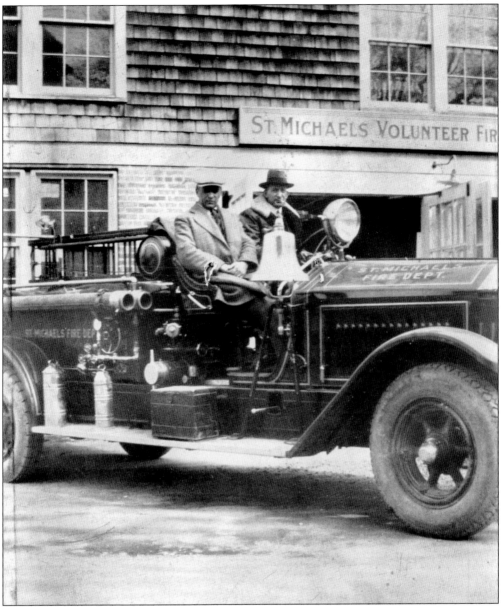

Gentlemen pose in the REO Speedwagon in front of the old St. Michaels firehouse when it was located behind Christ Episcopal Church in the 1930s. (Courtesy of the St. Michaels Volunteer Fire Department.)

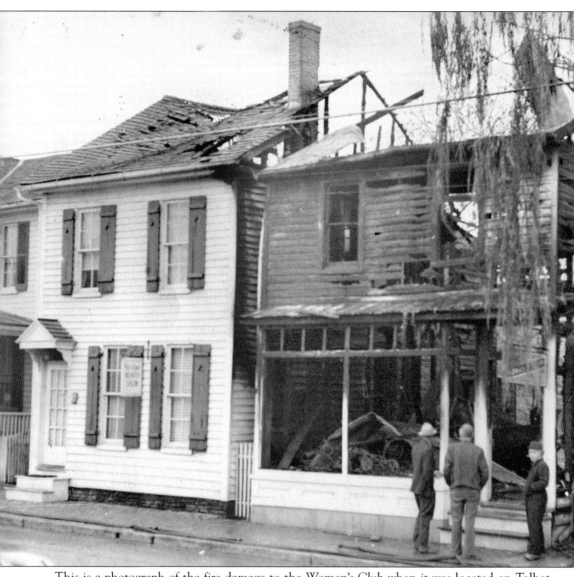

This is a photograph of the fire damage to the Women's Club when it was located on Talbot Street about 1940. The club is now located on St. Mary's Square. (Courtesy of the St. Michaels Volunteer Fire Department.)

The second St. Michaels firehouse was built in 1956 behind Christ Episcopal Church. The building was razed in 2003, and a new firehouse was built just outside of town. (Courtesy of the St. Michaels Volunteer Fire Department.)

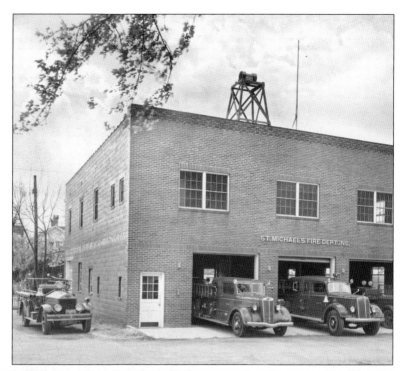

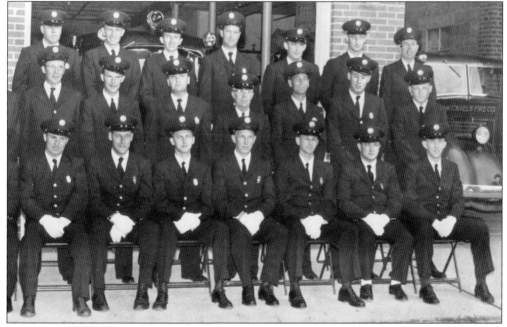

A smart photograph of the St. Michaels volunteer firefighters in their suits includes, from left to right, (first row) Albert Soulsman, Al Hinckel, Harry Caulk, Louis Murray, Paul Haddaway, Harold Griffith, and Beverly Bryan; (second row) Earl Jake Morris, Bill Shortall, Phil Dunn, Jim Ivans, Donald Parkerson, Pat Wooden, and Norman Row; (third row) Dink Daffin, Roland Lloyd, Eddie Shortall, Ellis Lednum, Horace Jefferson, Ralph Stacey, and Bud Shortall. (Courtesy of the St. Michaels Volunteer Fire Department.)

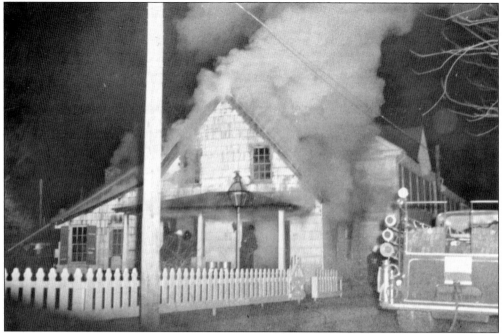

The preponderance of wood houses in St. Michaels and the surrounding area demonstrate the need for a well-trained fire company, as can be seen in this photograph of the Ortt house in flames c. 1956. (Courtesy of the St. Michaels Volunteer Fire Department.)

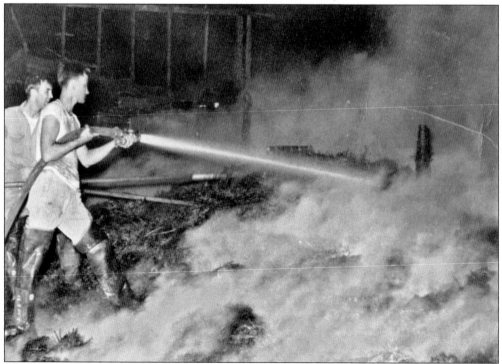

Firefighters Harry Caulk (left) and Ronny Dobson put out a blaze in 1957. (Courtesy of the St. Michaels Volunteer Fire Department.)

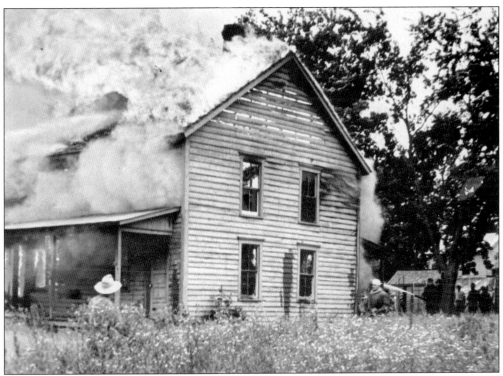

The St. Michaels Volunteer Fire Department is seen battling a blaze in an abandoned house near Royal Oak in the late 1950s. (Courtesy of the St. Michaels Volunteer Fire Department.)

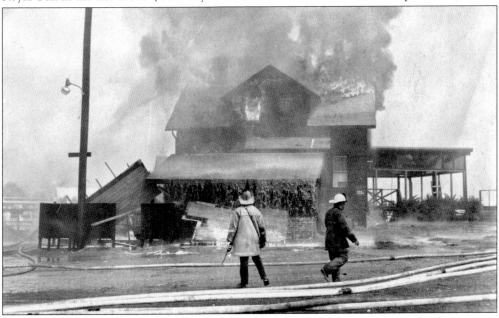

This is a 1970s photograph of the seafood packinghouse in flames by the town dock. This area was originally a shipyard and later, in the mid-1800s, the site of the steamship wharf and a canning factory. The town dock is still open for business, and the packinghouse has been replaced by two restaurants. (Courtesy of the St. Michaels Volunteer Fire Department.)

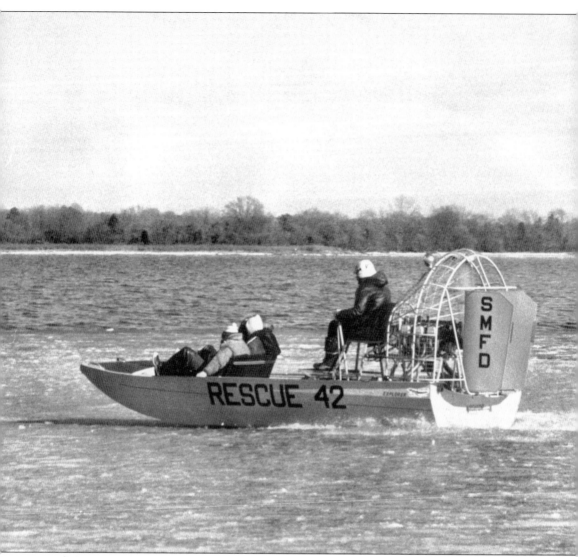

The St. Michaels Fire Department is ready for any emergency on land or on the water. The addition of a shallow-draft boat enables the fire company to deliver medical services as well as fire assistance when needed to occupants in distress on the water. (Courtesy of the St. Michaels Volunteer Fire Department.)

Seven

OUT OF TOWN

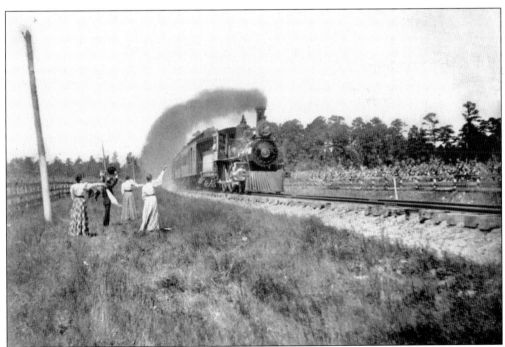

The *Ocean City Flyer* is on a run through Royal Oak with some local residents waving a greeting in 1895. As the halfway point between Easton and St. Michaels, Royal Oak was self-sufficient with churches, general stores, saloons, and boardinghouses run for summer guests. From this midway point, one can either continue west to St. Michaels or turn south to the town of Bellevue, where there is a ferry to Oxford. (Courtesy of the Talbot County Historical Society.)

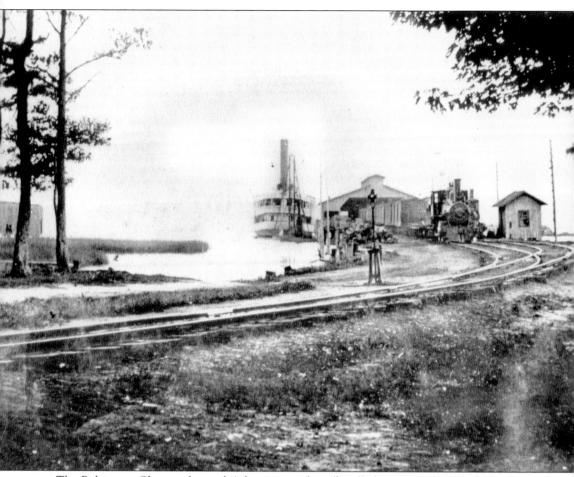

The Baltimore, Chesapeake, and Atlantic train line (locally known as the "Black Cinders and Ashes") ran to the Claiborne Wharf, where it met steamers who were delivering and picking up goods and passengers. From Claiborne, it would take about two hours to reach the beaches of Ocean City. This is a 1910 photograph of the steamer *Cambridge* docked at the train shed at Claiborne. (Courtesy of the Talbot County Historical Society.)

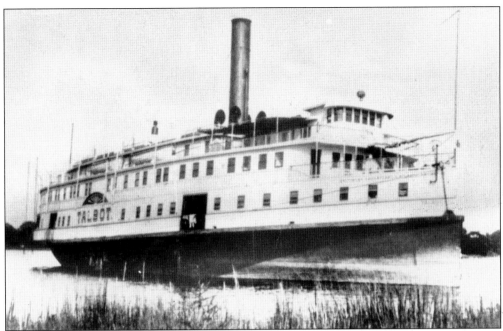

The *Talbot* was built in 1912 at a cost of $185,000. It was an inclined engine side-wheeler, 60 feet wide by 192 feet in length. This was considered a luxurious steamship, as it had staterooms on the upper decks, private bathrooms, and a top speed of 14.5 miles per hour. A full menu was offered in the dining room, and there was often entertainment on board. (Courtesy of the Talbot County Free Library.)

The Miracle House
CLAIBORNE, MD.

··◇·◇··

Maintained by the

Maryland Tuberculosis
Association, Inc.
900 Saint Paul Street

A preventorium for undernourished and underweight children of Maryland.

Fresh Air, Pure Food, Sunshine, Rest, Exercise and Health Training.

This work is made possible by the annual sale of Tuberculosis Christmas Seals, and Special Donations.

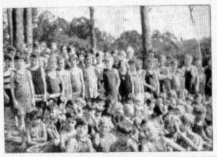

Many of Baltimore's poorer children spent their summers in Claiborne at the Miracle House, which was maintained by the Maryland Tuberculosis Association. It was believed that fresh air, exercise, and an improved diet would slow the spread of tuberculosis that was rampant in the crowded row homes of the city. (Author's collection.)

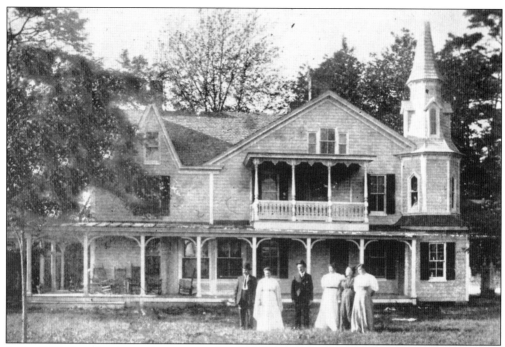

In the 1900s, boardinghouses became popular along the East Coast; this is identified as a photograph of Claiborne Hall. Boardinghouses advertised healthy air, good food, and relaxation to entice city dwellers to come for a visit. (Courtesy of the Talbot County Free Library.)

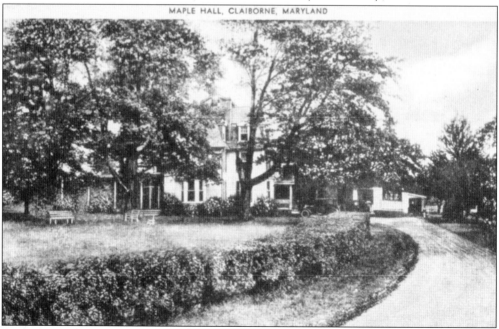

Maple Hall, just east from Claiborne, was run as a lodging house with 30 rooms available for weary travelers coming from the western shore via the steamships at the wharf in Claiborne. It was in operation as a boardinghouse until as late as 1967. Weekly rates for boarding around 1900 were between $6 and $7. (Courtesy of the St. Michaels Museum at St. Mary's Square.)

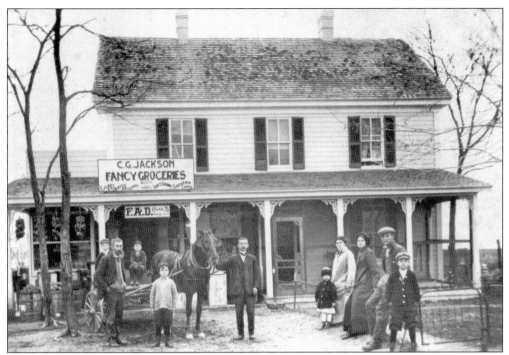

In this photograph of the Jackson General Store in Claiborne from the 1900s, one can get a sense of the importance of such places in small towns, where the stores operated as a gathering spot as well as a place to buy staples, notions, and tools and to pick up mail. The post office still operates out of this building today. (Courtesy of the Talbot County Free Library.)

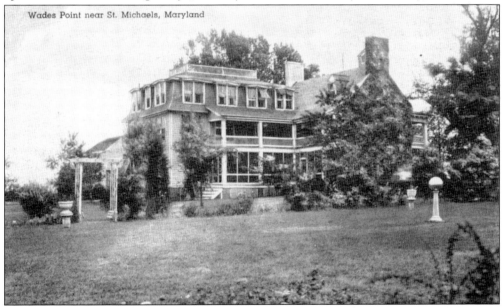

Another farmhouse, converted to a boardinghouse known as Wades Point, was built in 1820, although the land patent for the farm dates back to 1659, making it one of the original land grants in Talbot County. It is located near Wittman, several miles west of St. Michaels. (Courtesy of the Talbot County Free Library.)

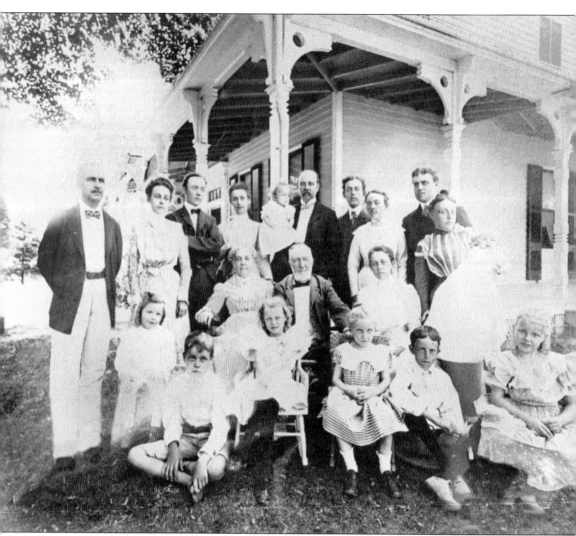

The Goldsboroughs, the Lloyds, the Hollydays, and the Tilghmans were the original power families settled in Talbot County in Colonial times. They owned vast farms and large houses, presided over the social scene, and held major political offices. This is a family photograph from the 1900s of the Goldsborough clan, whose ancestral estates, Ashby and Myrtle Grove, lie along the Miles River. (Courtesy of the Talbot County Historical Society.)

A late-1890s photograph shows the Fluharty House on Black Walnut Point, which is located at the southernmost tip of Tilghman Island. The island is named for Matthew Ward Tilghman of Rich Neck, who owned most of the land from Claiborne to Tilghman. The house displays a quirky architecture unique to the island. (Courtesy of the Talbot County Free Library.)

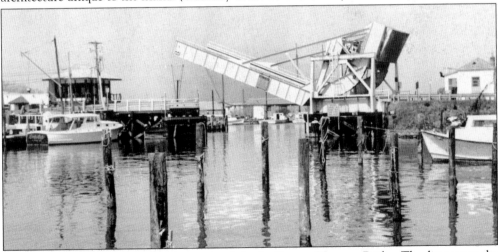

Tilghman Island is connected to the peninsula by the Knapps Narrows Bridge. The distance to the island from St. Michaels is roughly 12 miles, and the area was known chiefly for its boatbuilding of skipjacks and bugeyes and its proximity to the Chesapeake Bay. Originally there was a fixed bridge in 1775, replaced by a bridge that could accommodate two-way traffic in 1869. In 1932, a drawbridge was built, creating a faster route for larger boats to reach the Chesapeake Bay. (Courtesy of the Talbot County Free Library.)

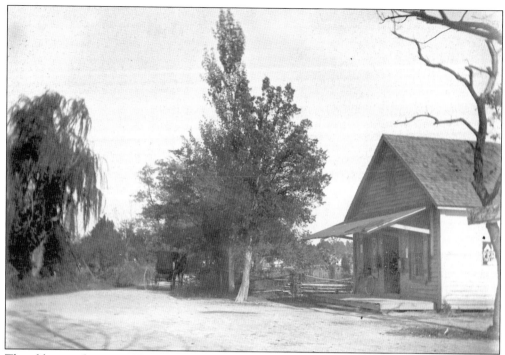

The old general store in Neavitt is still standing today, although long since closed for business. In the background, one can view a buggy just beyond the front porch in this 1906 photograph. (Courtesy of the Talbot County Historical Society.)

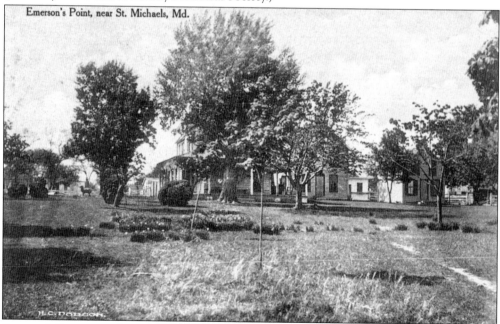

Emerson's Point, near St. Michaels, Md.

Emerson's Point was a farm and also a boardinghouse for city dwellers seeking a tranquil respite. Visitors would arrive by steamboat and railway and could look forward to fishing, boating, lawn tennis, and lemonade on the front porch. (Courtesy of the St. Michaels Museum at St. Mary's Square.)

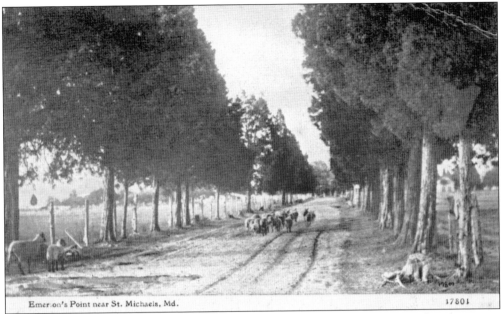

Emer:on's Point near St. Michaels, Md. 17801

A flock of sheep on the road to Emerson's Point farm in 1906 reminds readers that these were primarily working farms; with the booming tourism industry at the beginning of the 20th century, families were able to let rooms and provide board to city-weary travelers from the western shore and points north. (Courtesy of the St. Michaels Museum at St. Mary's Square.)

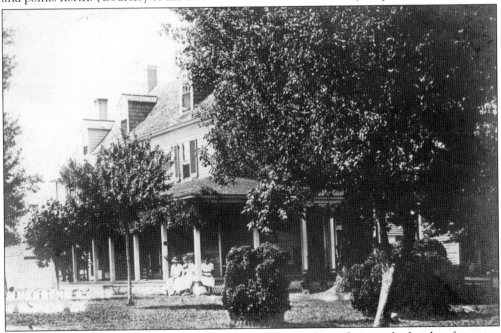

Several young ladies rest on the front porch at Emerson's Point farm at the height of summer around 1907. Clapboard houses with deep porches and overplanted with trees and shrubs were a natural sight in the area. The dense plantings protected the house from the elements and kept the porch cool in the days before air conditioners. (Courtesy of the St. Michaels Museum at St. Mary's Square.)

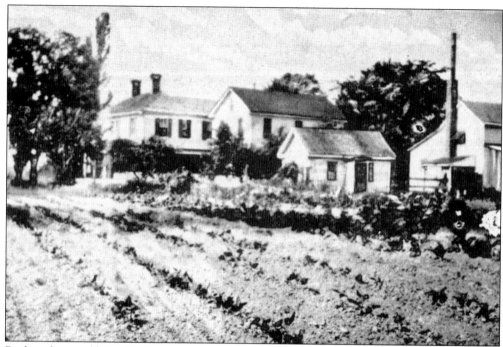

Backyard vegetable gardens were a necessity for residents around the early 20th century. Even today, one can see some remnants of the old gardens, marked by grape arbors, picket fences, and garden sheds. This is a view of the Willows, a working farm and boardinghouse outside of St. Michaels in the 1900s. (Courtesy of the St. Michaels Museum at St. Mary's Square.)

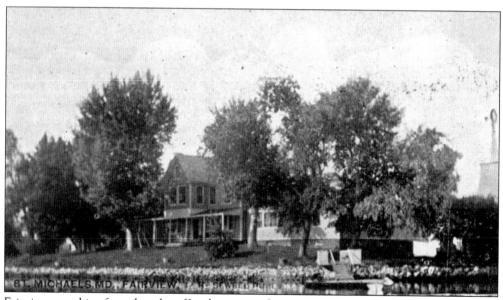

Fairview, a working farm that also offered accommodations to visitors during the summer months, can be seen in this postcard from 1906. To the right of the picture is a windmill; these were quite common on large farms located a distance away from gristmills. (Courtesy of the St. Michaels Museum at St. Mary's Square.)

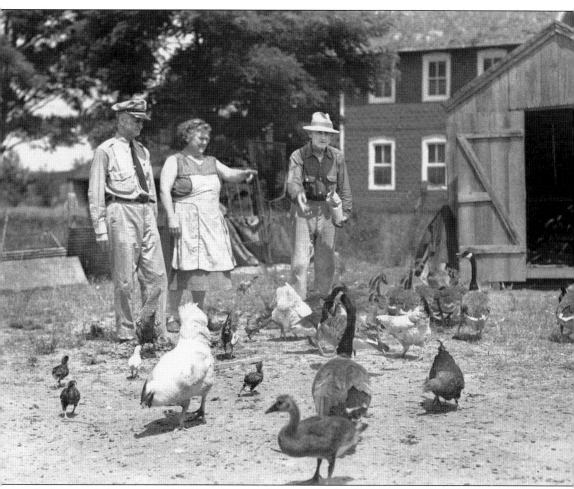

A photograph from around the 1940s shows feeding time for the chicks, hens, and a few domesticated Canadian geese, a common sight around the area. Poultry was and still is an important part of the economy on the Delmarva Peninsula. (Courtesy of the Talbot County Historical Society.)

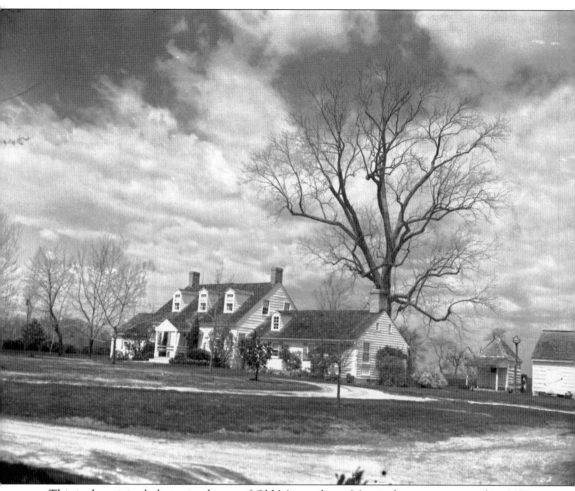

This is the original plantation house of Old Martingham. Martingham was surveyed in 1659 as 200 acres and remained in the venerable Hambleton family for many generations. It was on an adjacent farm that Frederick Douglass spent a few years working in the fields before he made his daring escape to freedom. (Courtesy of the Talbot County Free Library.)

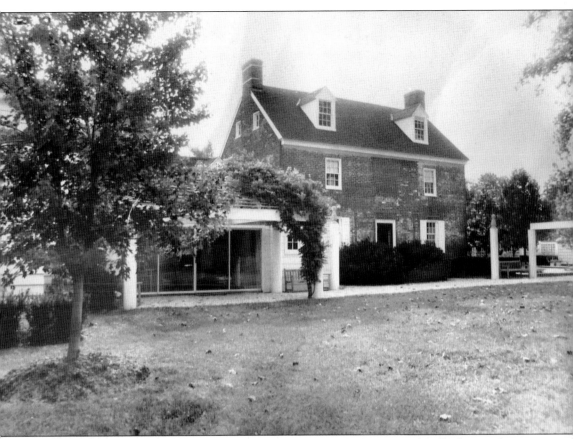

The old plantation manor house of Mount Misery, dating from 1804, is locally famous for its history in relation to Frederick Douglass. Located south of St. Michaels, it is one of the original plantation dwellings in the area. The name Mount Misery, according to legend, comes from Jamaica, where there was a strong local connection with St. Michaels in the sugar and slave trade. Edward Covey, the notorious slave-breaker who had Frederick Douglass in his charge, owned the property. (Courtesy of the Talbot County Free Library.)

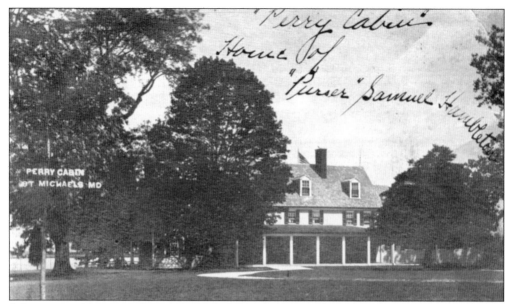

Subsequent additions and renovations have made Perry Cabin farm into the grand hotel and conference center it is today. Originally a plantation dating from the 1800s, it was operated from the mid-1960s to 1980 as a private house with a riding academy, sporting a coach house and a magnificent indoor arena with a crystal chandelier as well as several tenancies for the workers. The coach house is now part of the main building, and a pool was installed on the grounds of the riding ring. There are now several large additions to host overnight guests to the right of the main house. (Courtesy of the St. Michaels Museum at St. Mary's Square.)

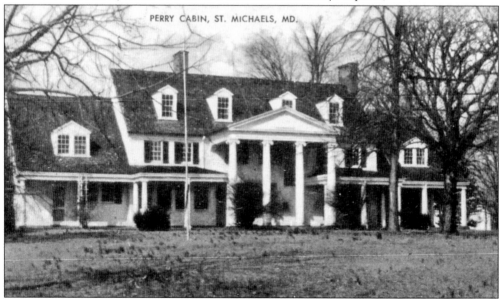

A postcard of Perry Cabin farm in the 1900s shows the portico facing the Miles River. Many houses of this type were constructed so the main entrance faced the commerce side on the water. The farmhouse was built around 1800, later additions in the 1920s created the revivalist look, and later still in the 1980s, after Elsie Hunteman sold the property, it was drastically altered to its current state. (Courtesy of the St. Michaels Museum at St. Mary's Square.)

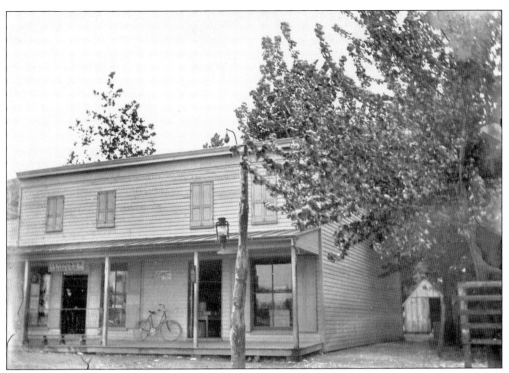

George Albert Seymour's general store in Royal Oak, shown in the 1890s, is now in use as an antiques shop run by the Kilmon family, who have been a presence in the town from at least the mid-1800s. (Courtesy of the Talbot County Free Library.)

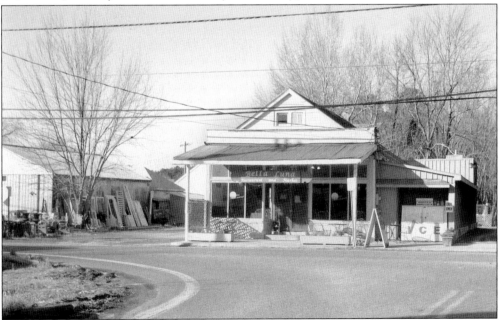

Royal Oak General Store was still run as a place to buy general merchandise and penny candy in the early 1970s. From that time, it underwent several incarnations as an ice cream parlor, antiques mart, and today as a restaurant. (Author's collection.)

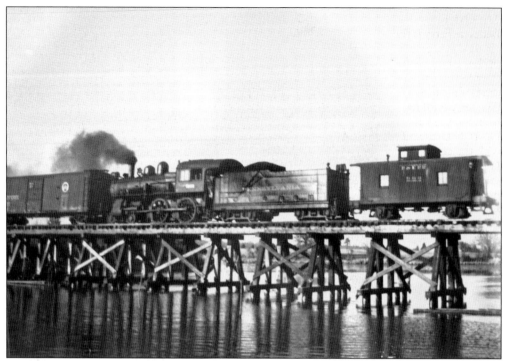

The Baltimore, Chesapeake, and Atlantic train (the Black Cinders and Ashes) ran to the Claiborne Wharf, where it met steamers who were delivering and picking up goods and passengers. From Claiborne, it would take about two hours to reach the beaches of Ocean City. Trestle bridges were built across marshy areas and creeks to facilitate train travel. (Courtesy of the Talbot County Historical Society.)

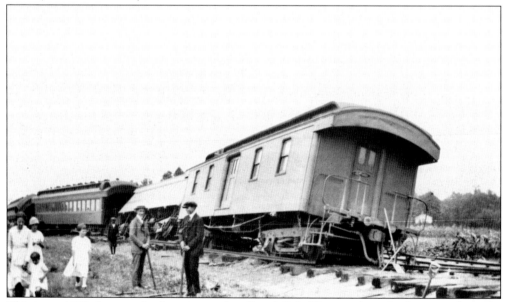

This is a c. 1910 photograph of a train wreck at Royal Oak. The people in the foreground may be evacuated passengers; the story behind this photograph was not recorded other than its location. (Courtesy of the Talbot County Historical Society.)

The Oxford-Bellevue Ferry is the oldest continuously operated non-cable ferry in the nation, established in 1683. The ferry itself has been replaced as needs dictated and with the change of transportation; today it can carry nine cars plus passengers and is the shortest distance between St. Michaels and Oxford. (Courtesy of the Talbot County Historical Society.)

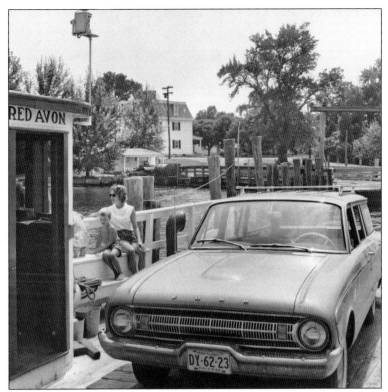

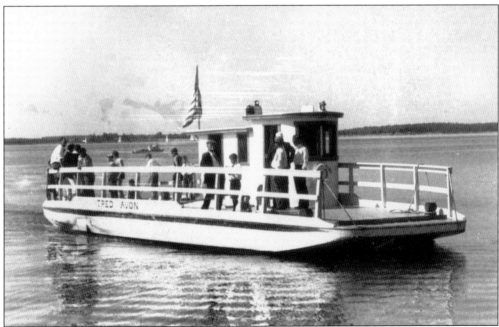

The Oxford-Bellevue Ferry in the 1950s leaves the Oxford wharf. The ride takes about 10 minutes across the Tred Avon River; even today, if one is on the Bellevue side needing a ride, there is a wooden "flag" one can raise to signal the ferry. The ferry is usually in operation from March to October. (Courtesy of the Talbot County Free Library.)

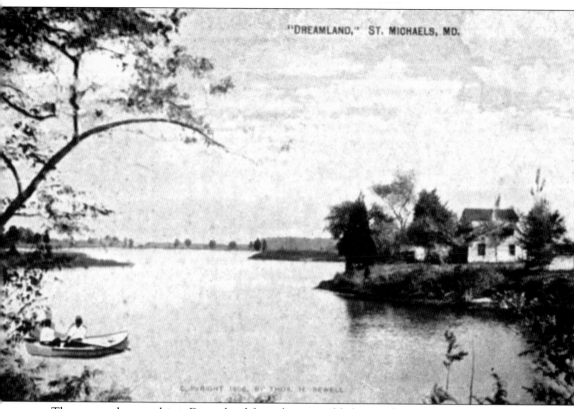

"DREAMLAND," ST. MICHAELS, MD.

The postcard states this is Dreamland farm, but more likely it is the cove at Emerson's Point in McDaniel *c.* 1907. There were many postcards made of the scenic areas around the boardinghouses for guests; oftentimes the photographer would exercise poetic license in titling the views. (Courtesy of the St. Michaels Museum at St. Mary's Square.)

Eight

AT WORK

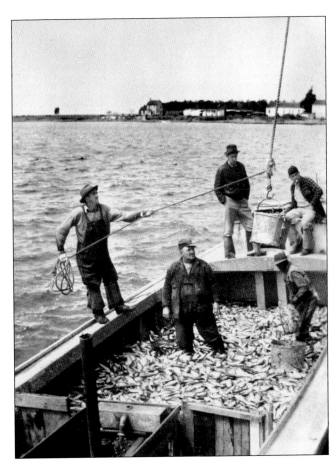

This 1920s photograph shows the unloading of fish by bucket to the processing plant. (Courtesy of the Talbot County Free Library.)

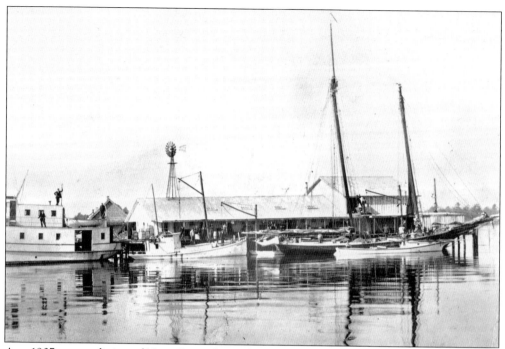

A *c.* 1907 postcard view of Navy Point shows the packinghouses in the distance. At this time, there were three packinghouses, processing oysters, crabmeat, and tomatoes. The area is now given over to a museum and restaurant. (Courtesy of the St. Michaels Museum at St. Mary's Square.)

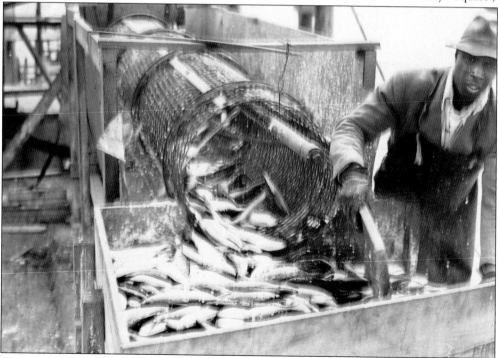

This waterman is rolling fish through a drum at the packinghouse in preparation for processing in the 1930s. (Courtesy of the Talbot County Free Library.)

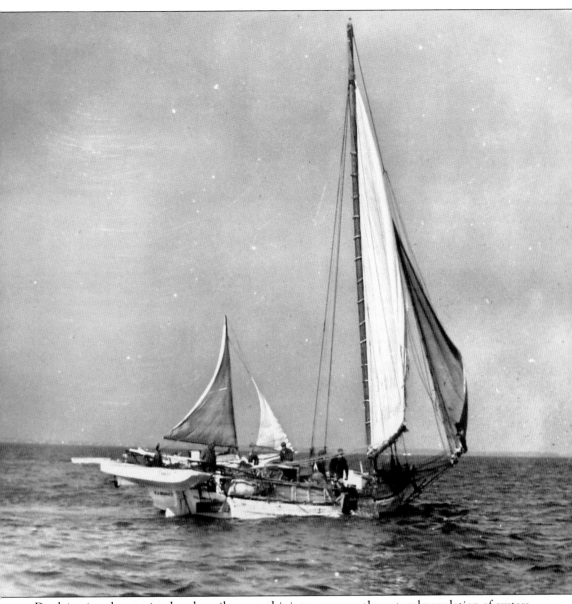

Dredging is only permitted under sail power; this is to conserve the natural population of oysters against over-harvesting. Out of the thousands of skipjacks that plied the bay at the end of the 19th century, only 19 are in existence today. (Courtesy of the Talbot County Free Library.)

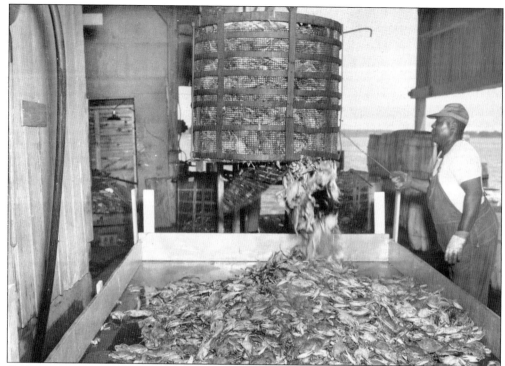

Crabs are seen here being sorted after harvesting for delivery to restaurants. Crabbing still remains one of the top local industries. (Courtesy of the Talbot County Historical Society.)

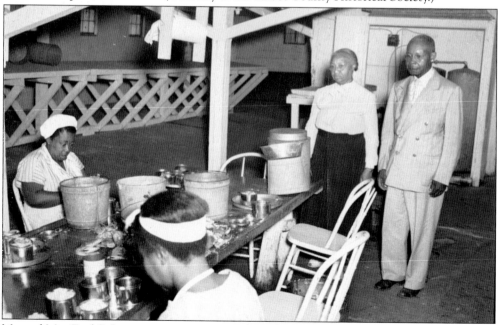

Mr. and Mrs. Fred S. Jewett were part owners of Coulbourne and Jewett Seafood Packing Plant. This photograph shows them in their crab packing plant in the 1940s. Fred Jewett was a leader in the shellfish packing industry, and his innovations are still in use today. He devised the system of identifying crabmeat as lump and backfin. (Courtesy of the Talbot County Historical Society.)

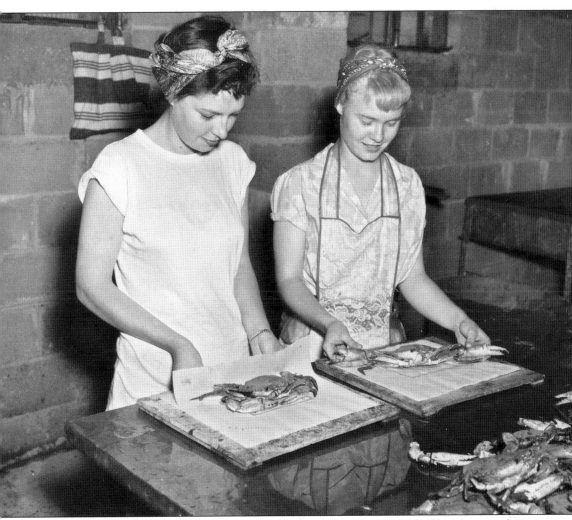

Two young ladies are seen here packing steamed crabs for shipment in 1950. This photograph is somewhat deceiving: the processing of crabs is a hot, messy job involving long hours during the season. (Courtesy of the Talbot County Historical Society.)

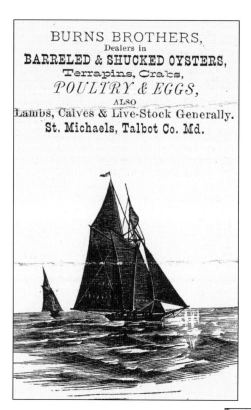

An example of an advertising poster from c. 1900 offers oysters, terrapins, crabs, poultry, eggs, and livestock for delivery via skipjack. (Courtesy of the Talbot County Free Library.)

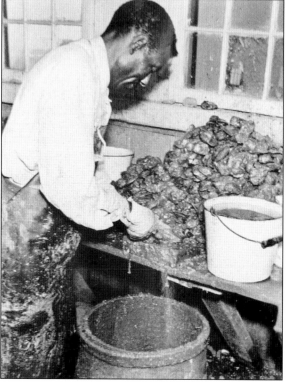

There are no machines to shell an oyster. Those who do it for a living are masters: armed with a short, sharp knife, protective gloves, and an apron, this gentleman will spend hours working in the wet and cold as oysters are harvested during the fall and early winter. The craze for oysters reached its peak during the late 1800s; the New England area by this time had already over-harvested their waters and was importing oysters from the Chesapeake Bay to fill the demand. (Courtesy of the Talbot County Free Library.)

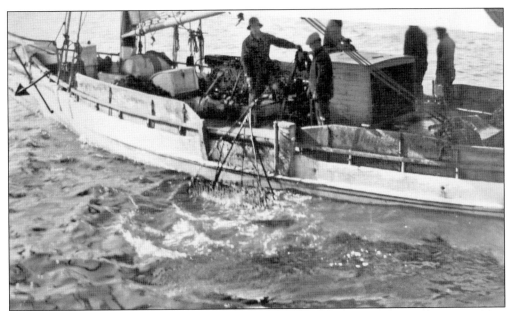

A view of an oyster scrape being hauled up onboard the skipjack in the 1920s demonstrates the manual force needed to make a living from the water. In every town where fishing was the main industry, there was usually a blacksmith or ironworker who could fashion the tongs and scrapes used by the watermen. These men were known for their particular metal work, and the efficiency of their implements nearly cleared the oyster beds bare by the 1900s. (Courtesy of the Talbot County Free Library.)

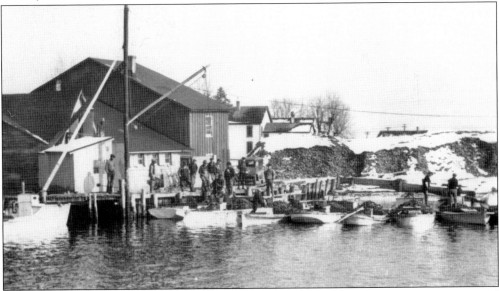

Skipjacks unload their oyster catch at the packinghouse in the 1950s. Oysters need to be processed quickly or they spoil; once they were harvested, the process of unloading, cleaning, shucking, and packing into sterilized cans was completed efficiently. During the season, packinghouse workers might put in 12-hour days in cold and damp conditions. After canning, the oysters were then reloaded onto "pungies" or skipjacks for the trip to Baltimore in the era before the construction of the Bay Bridge. (Courtesy of the Talbot County Free Library.)

The "bay built" boat replaced the masted skipjacks with the introduction of the gasoline engine. With a shallower draft, these workboats could navigate into small coves and closer in to sand bars for oyster tonging. While not as romantic looking as the older sailing vessels, they are much easier to maintain and use by watermen. (Courtesy of the Talbot County Free Library.)

In this 1970s view, a waterman unloads his oyster haul into trucks bound for Baltimore, the method for transporting fresh seafood to the restaurants. This is the wharf at Bellevue across the Tred Avon River from Oxford, which has historically been an African American enclave that boasted several oyster packing plants by the 1900s. (Courtesy of the Talbot County Free Library.)

Ox-drawn carts on dirt roads were a common sight in the area until trucks became more common as a means to transport goods. There were grist and flour mills in the area; after processing, the usual way to deliver flour and grain was by boat. Mule carts or trucks would meet small skiffs at the water, and the boats would then be loaded. The skiff would then meet a larger transport boat such as a skipjack bound for Baltimore and transfer its cargo. It is mainly for this reason that large plantations and farmhouses were located along the shoreline. (Courtesy of the Talbot County Historical Society.)

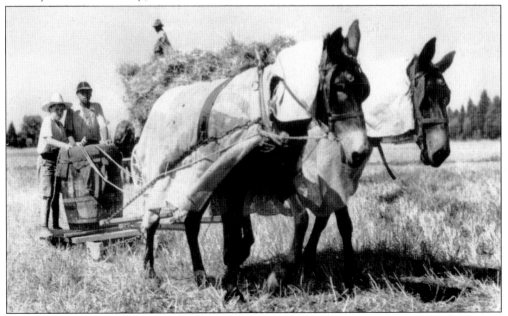

This is a side view of the hay harvest with two boys manning a two-mule cart sometime in the 1930s. Teenagers often left school early or at least when harvest time came around in order to help the family. (Courtesy of the Talbot County Free Library.)

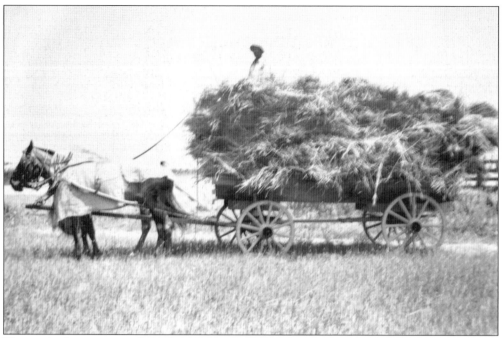

This mule-drawn wagon from the 1930s is loaded and on its way to the thresher. Threshing machines greatly improved the efficiency of harvesting as well as improving the working conditions of the farmers. (Courtesy of the Talbot County Free Library.)

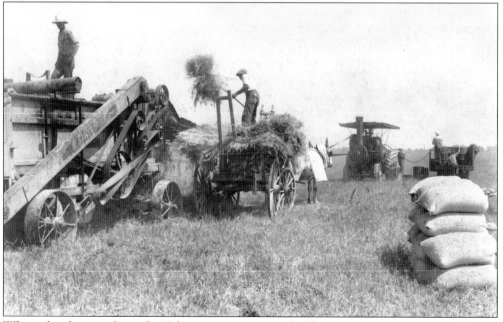

Wheat threshers in the early 20th century were a profitable improvement over manual labor, both saving time and minimizing waste. Most of the land around St. Michaels is arable; this is an example of what one might see on a farm during harvest time. Joe Watts is on the thresher, and Bill Bryan was co-owner of this Nichols and Shepherd thresher. The bags of wheat to the right are ready for loading. (Courtesy of the Talbot County Free Library.)

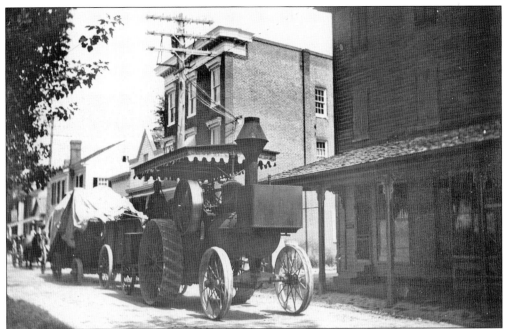

This is a view of Talbot Street when it was a dirt road in 1905. The innovations in machinery at the beginning of the 20th century brought positive change to farmers who could afford to invest in them. This is a Buffalo-Pitts tractor hauling a wagon and some threshing equipment through town at the corner of Talbot and Carpenter Streets. (Courtesy of the Talbot County Historical Society.)

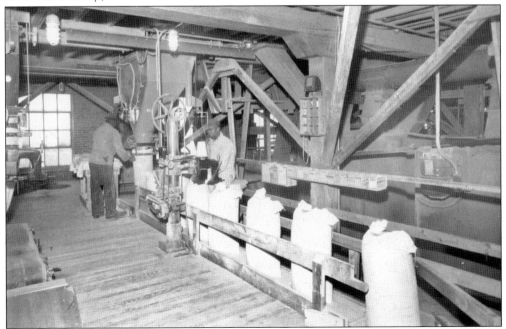

The flour processing mill on East Chew Avenue was still in use until the late 1970s; here is a photograph from the 1940s of the mill still at work. (Courtesy of the Talbot County Free Library.)

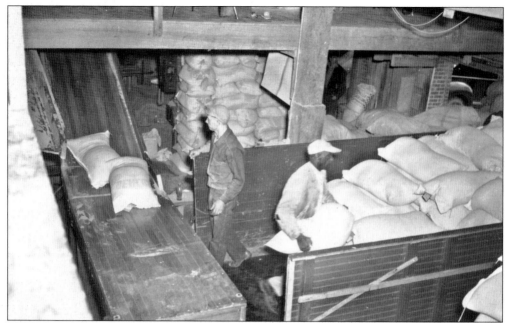

The St. Michaels Flour Mill on Chew Avenue is still standing today—no longer operating as a mill but hosting a variety of shops. The brick building dates from 1890 and was a great source of pride in the area, demonstrating a high level of self-sufficiency as well as a profitable export business. Before the mills, most large estates had windmills on site to grind corn and wheat; a few of these are still visible from the water today. (Courtesy of the Talbot County Free Library.)

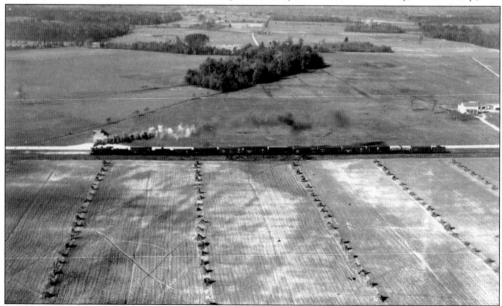

A steam train runs through a harvested hay field around 1940. Trains at this time would carry passengers as well as cargo. The survival of farm animals in the winter depended on a good crop of hay and corn, and up until the 1980s, the area was almost all farmland. This is a photograph of threshed and stacked hay from the 1940s, a method no longer in use today. (Courtesy of the Talbot County Historical Society.)

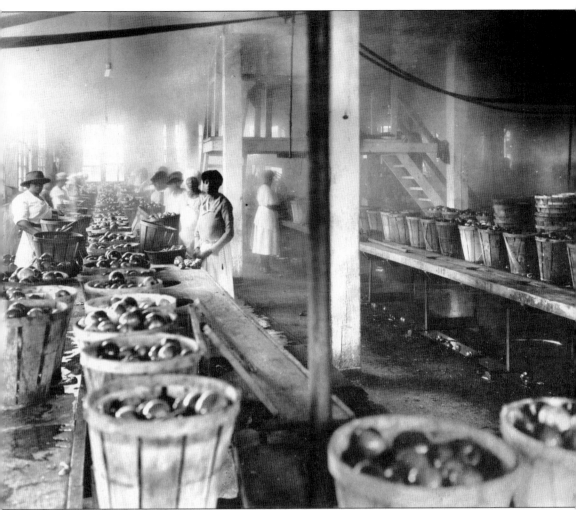

Canning and packing plants were mostly centered on Navy Point in the St. Michaels area and were in operation until the 1950s. Five canning plants were owned by Harrison and Jarboe. Harrison and Jarboe had the distinction during the war years of packing more canned tomatoes than the Campbell Soup Company, for which they were honored by the U.S. government. This interior photograph of women sorting bushels of apples was taken in the late 1930s. (Courtesy of the Talbot County Historical Society.)

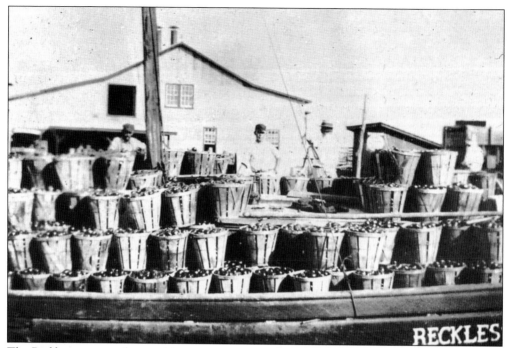

RECKLES

The *Reckless* was one of many ships transporting produce to Baltimore in 1890; here she is loaded with bushels of tomatoes. Most kinds of produce are grown in the area, but tomatoes, strawberries, peaches, and corn do particularly well in the sandy soil. Produce would be loaded on carts or trucks and could be transported either by schooner or steam train for Baltimore, Washington, D.C., and north to Philadelphia and New England. (Courtesy of the Talbot County Historical Society.)

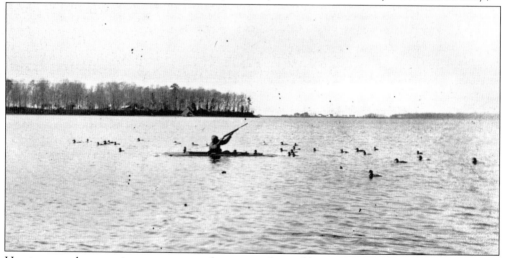

Hunters are always trying to outsmart their prey; the sinkbox is one method that is employed locally with some success. The boat itself resembles a small wooden coffin; it has planks attached that extend flat across the water. The hunter can sit or lie flat at water level with his decoys spread around. This method can be used in shallow or deep water, but if the water is choppy, it's a soggy wait. Around the end of the 19th and beginning of the 20th century, families depended on hunting for food and income; the old phrase "no duck, no dinner" was taken seriously. (Courtesy of the Talbot County Free Library.)

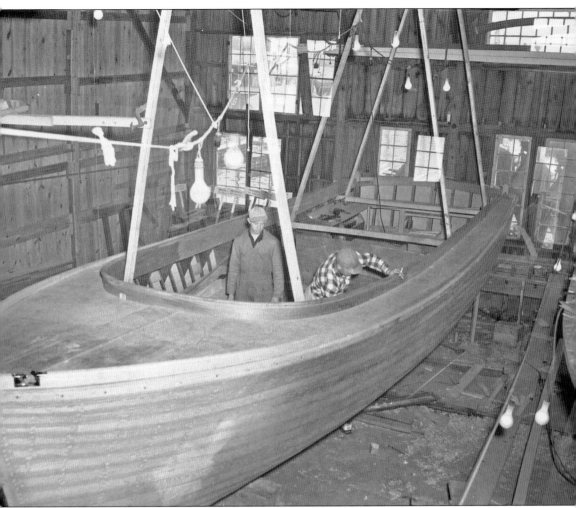

Boatbuilding had always been a major industry in the area until the supply of suitable wood was depleted. Shipyards ringed St. Michaels harbor and were also located out of town. Some shipbuilders operating in the early 1800s included Joseph Hergesheimer, Robert Lamdin, Impey Dawson, Thomas Haddaway, and John Wrightson. This is a 1950s view of ship carpenters at work. (Courtesy of the Talbot County Historical Society.)

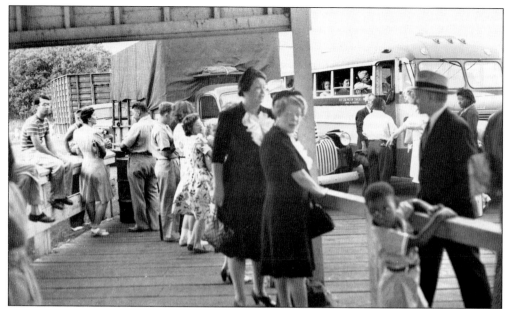

A passenger ferry is ready to leave for its destination. Cars were maneuvered onto the lower decks and parked to distribute weight as evenly as possible. Blocks of wood were placed under the tires to prevent rolling in case of a sudden stop or bad weather. The ferry service between Claiborne and Romancoke ended on December 31, 1952. (Courtesy of the Talbot County Historical Society.)

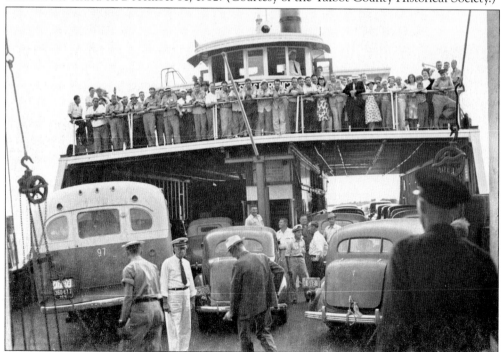

People wait on board a passenger ferry c. 1940. With the opening of the Chesapeake Bay Bridge in 1952, passenger ferries ended their service on the bay, although there are still smaller river ferries in operation, most notably the Oxford-Bellevue Ferry connecting St. Michaels with Oxford. (Courtesy of the Talbot County Historical Society.)

Nine

AT LEISURE

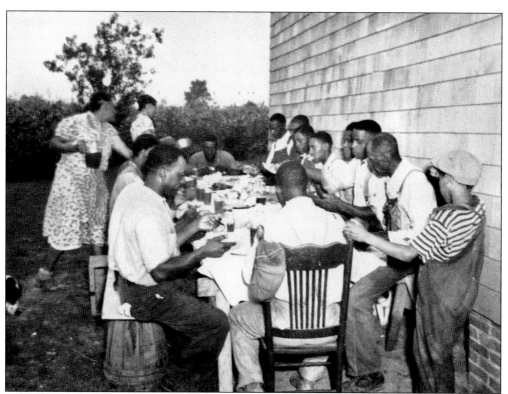

One of the pleasures of summertime is relaxing outside in the early evening, enjoying dinner featuring crab cakes, fried fish, local sweet corn, hush puppies, and potato salad. Every local family has its own special recipes, handed down to later generations and a just source of pride at every gathering where food is featured. This photograph was taken around 1940. (Courtesy of the Talbot County Historical Society.)

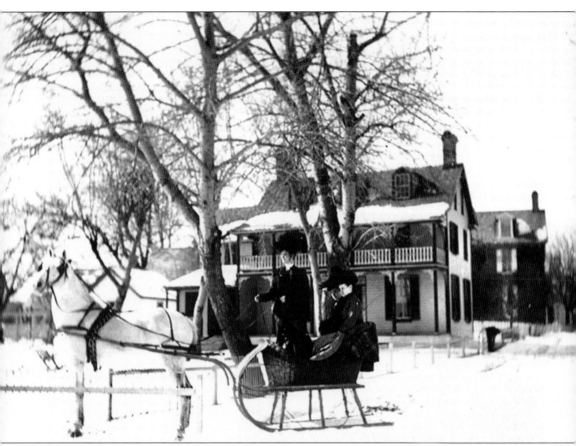

These stylish ladies have hitched up a fine horse to pull their sleigh through town in a rare winter snow around 1907. They are stopped in front of the Edward Willey house, built in 1850, on the east end of Cherry Street facing the Honeymoon Bridge. (Courtesy of the St. Michaels Museum at St. Mary's Square.)

It's 1907, there is snow on the ground, and some residents on Chew Avenue have decided to get together for some fun and to pose for a photograph. There is an assorted mix of animals pulling sleds—two goats, a horse, and a donkey—and it looks perhaps like a race might be in the works. (Courtesy of the St. Michaels Museum at St. Mary's Square.)

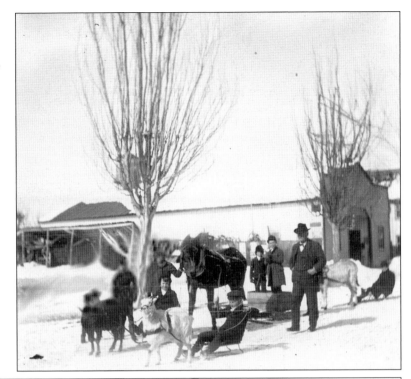

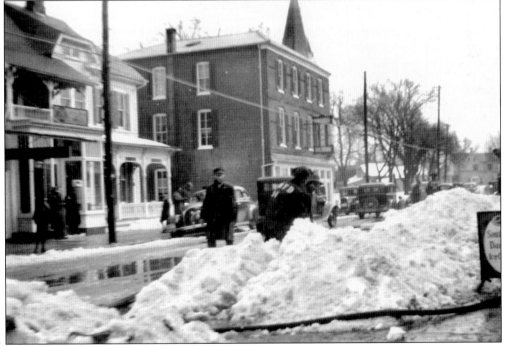

Snow does not come often to the St. Michaels area; if anything, ice has always been a bigger problem in the winter, as it prevents the workboats from accessing the river. When it does snow, however, it brings out the residents, as seen in this view of Talbot Street in the 1930s. (Courtesy of the St. Michaels Volunteer Fire Department.)

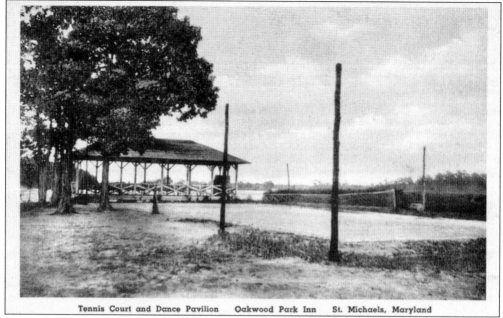

Tennis Court and Dance Pavilion Oakwood Park Inn St. Michaels, Maryland

This postcard of the tennis court and dance pavilion at the Oakwood Inn was probably used for advertising in the 1930s; such establishments brought business and employed townspeople during the summer months. (Courtesy of the St. Michaels Museum at St. Mary's Square.)

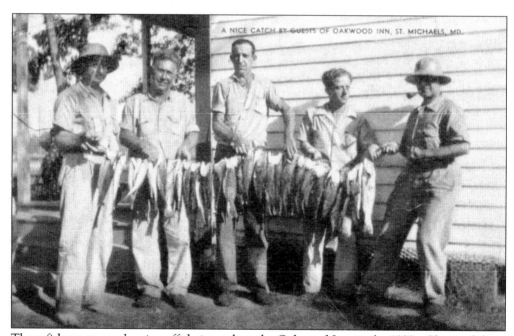

A NICE CATCH BY GUESTS OF OAKWOOD INN, ST. MICHAELS, MD.

These fishermen are showing off their catch at the Oakwood Inn in the 1930s. Charter fishing in the summer and guided hunting in the fall and winter are still a big industry in the area. St. Michaels' proximity to the Chesapeake Bay makes it an ideal starting point for those wanting to fish in more exciting waters. (Courtesy of the St. Michaels Museum at St. Mary's Square.)

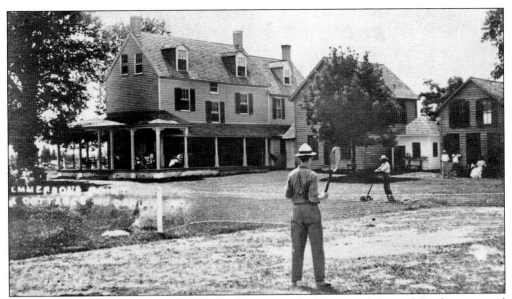

Two boarders are playing lawn tennis in this postcard of Emerson's Point farm from around 1907. The entertainments at the farms offering lodging to boarders were pretty basic: tennis, rowboating, bicycling, and swimming. Trips into town might offer dancing and music on the weekends. Notice the ladies relaxing in rockers under the shade of the porch. (Courtesy of the St. Michaels Museum at St. Mary's Square.)

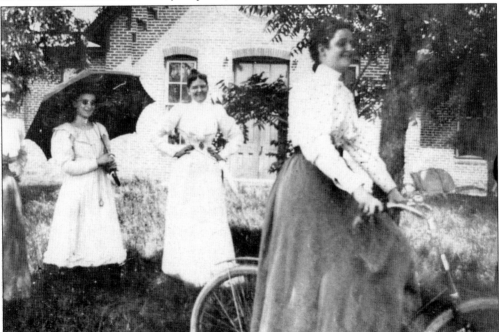

Florence Cunningham and some friends near St. Luke's Church are contemplating a bicycle ride on a summer day in 1906. The area's flat terrain is a boon to bicyclers of all ages and levels; in the late 1970s, bike trails were established the length of the highway from Easton to Tilghman Island to afford enthusiasts another way to enjoy the scenery. (Courtesy of the St. Michaels Museum at St. Mary's Square.)

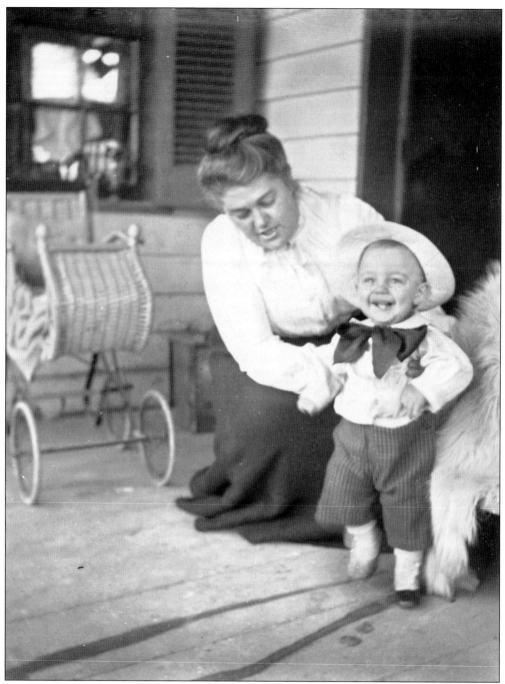

E. Nelly Dodson is seen here with her toddler, who is just learning to walk and having a good laugh while his photograph is being taken. There is a wicker pram behind them on the front porch; this photograph dates from around 1906. (Courtesy of the St. Michaels Museum at St. Mary's Square.)

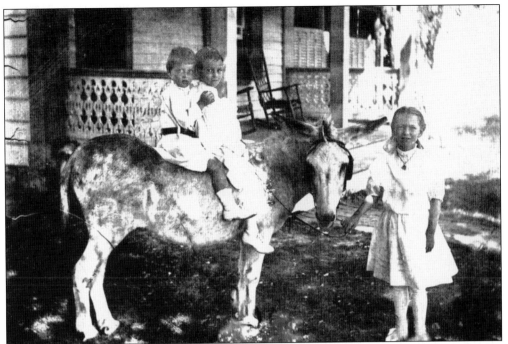

The Dodson children are seen here with Mame, their Egyptian donkey, in the early 1900s. Their father brought the donkey back from his travels around the world as a souvenir for his children. (Courtesy of the St. Michaels Museum at St. Mary's Square.)

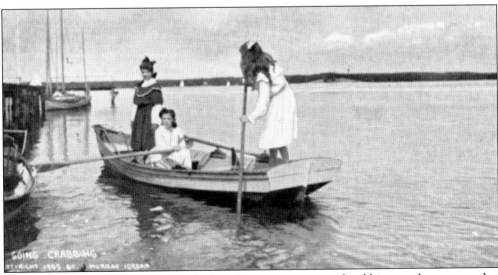

We might laugh today to see young girls dressed up to go rowing and crabbing on a hot summer day, but this was 1905, and proper young ladies were always completely covered. This postcard shows how children dressed for play at the beginning of the 20th century. (Author's collection.)

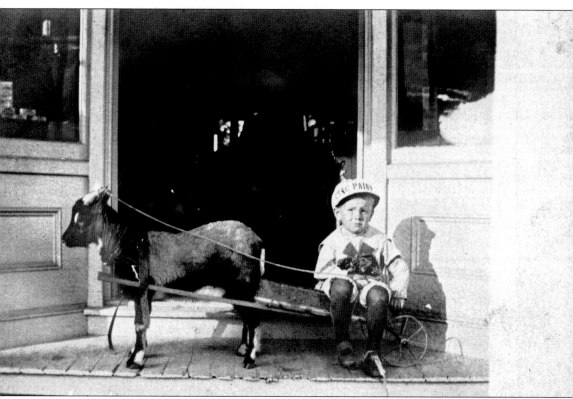

One may ask what did children do for fun in a town before television, movies, and electronic games? The answer is they made their own fun with what they had available: this young fellow has hitched up his goat to a cart made from an apple crate and is seen here posing in front of Harrison's Pharmacy in the early 1900s. (Courtesy of the St. Michaels Museum at St. Mary's Square.)

Harrisons' Pharmacy was in operation from the late 1870s until the 1970s, selling goods and medicines and operating a lunch counter. E. G. Harrison was the proprietor; here we see him on Talbot Street in front of his pharmacy, looking dapper with cigar in hand, c. 1900. (Courtesy of the St. Michaels Museum at St. Mary's Square.)

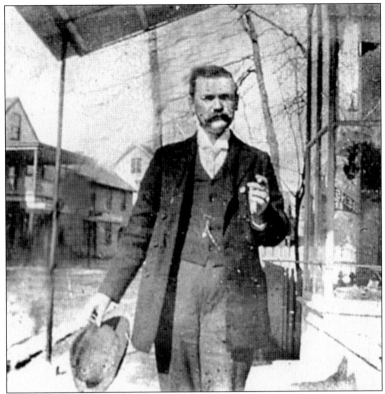

It must be remembered that St. Michaels was very much a working town during its first 200 years, with most residents either operating businesses or fishing the waters or farming for their livelihoods. This is an early-morning view of townsfolk going about their business on the corner of Front and Cherry Streets at Lidia Williams's general merchandise store around 1900. (Courtesy of the St. Michaels Museum at St. Mary's Square.)

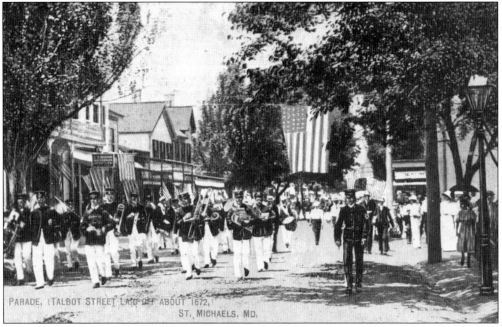

PARADE, (TALBOT STREET LAID OFF ABOUT 1672,)
ST. MICHAELS, MD.

Seen here is a view of Talbot Street draped with American flags for a Fourth of July parade in 1907. Parades were usually the patriotic start to a town celebration, featuring marching bands, local delicacies, contests, and dancing into the night. (Courtesy of the St. Michaels Museum at St. Mary's Square.)

FOURTH OF JULY

GRAND AND GLORIOUS CELEBRATION
AT
ST. MICHAELS, MD.
ON
ST. MARY'S SQUARE
Following
THE BIG STREET PARADE
AT 12.30 P. M.

If you are in St. Michaels s there if you are not get tnere and enjoy a glorious Fourth. The Riverside Band of St. Michaels will be on the job with plenty of music and a splendid program.

Be sure to enter your name in the following contests before 6 p. m. July 3d.

CATCHING GREASY PIG. PRIZE $5.00
"If you have ever laughed come laugh again"

Champion Pillow Fighter. Prize $2.50
"Don't miss it, more fun"

Pie Eating Contest, 1st Prize $2.00; 2nd Prize $1.00
"Laugh and the world laughs with you; Eat and the world laughs at you"

Bag Race, 1st Prize $2.00; 2nd Prize $1.00
"Bag your feet not your head"
Other Stunts equally as amusing will be performed

ADMISSION, ADULTS 25 CENTS CHILDREN 10 CENTS

BASE BALL GAME WILL FOLLOW
STREET DANCE AT 8.30 P. M.
Buy Your Ticket Early, Price 25 Cents
Under the auspices of the Riverside Band of St. Michaels

A poster announces the Fourth of July parade featuring the music of the Riverside Band of St. Michaels and various events, including "Catching Greasy Pig," "Champion Pillow Fighter," a pie-eating contest, a bag race, a baseball game, and a street dance at 8:30 p.m. (Courtesy of the St. Michaels Museum at St. Mary's Square.)

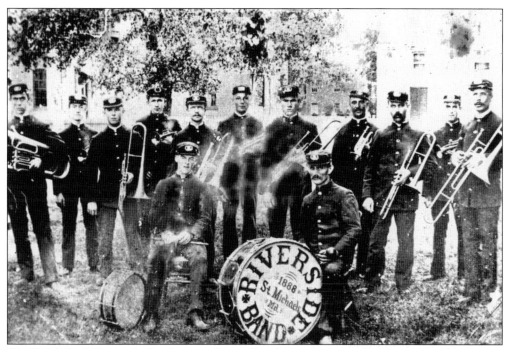

The St. Michaels Riverside Band was made up of local musicians providing summer entertainment for the townspeople and visitors on weekends and holidays. This view taken in 1888 shows the band in uniform. (Courtesy of the St. Michaels Museum at St. Mary's Square.)

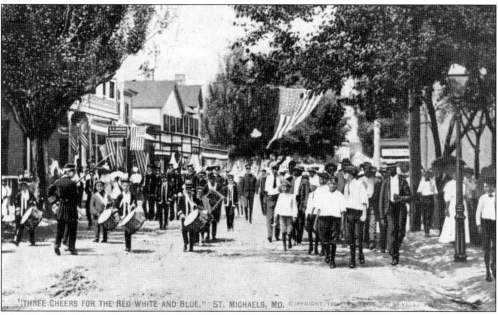

This "Three Cheers for the Red, White and Blue" postcard of the July 4 parade shows the townspeople of St. Michaels enjoying the patriotic celebrations that were popular in the years after the Civil War. (Courtesy of the St. Michaels Museum at St. Mary's Square.)

A romantic postcard view of the Green Street Thoroughfare overlooking the harbor in 1907 shows the crushed oyster-shell roads and tree-shaded walkways that were prevalent in the town from this time. The view is only slightly different today; much of St. Michaels retains its original streetscapes from more than 100 years ago. (Courtesy of the St. Michaels Museum at St. Mary's Square.)

This is a poster printed by Comet Print of St. Michaels announcing the Centennial Celebration, which featured two baseball games between St. Michaels and the Baltimore Yanegans, a grand parade, and an evening of fireworks. (Courtesy of the St. Michaels Museum at St. Mary's Square.)

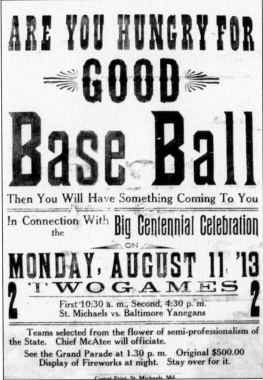

In this group photograph from the 1970s is the Little League team sponsored by Evey's TV and Appliances. The Eastern Shore has contributed several greats to the legion of baseball, including Frank "Homerun" Baker from Trappe, Jimmy Foxx from Sudlersville, and St. Michaels' own Harold Baines of the Chicago White Sox. (Courtesy of the Talbot County Historical Society.)

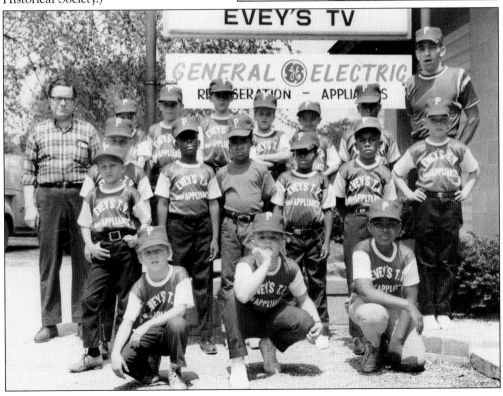

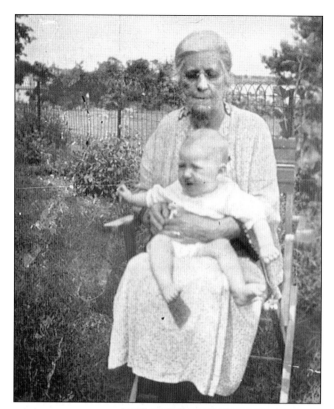

This is a photograph of Mary Elizabeth Harrison holding her grandson Robert Shockley in 1936. The Harrisons were major landowners in the Colonial era, being given a land grant of 2,000 acres from Lord Baltimore in 1663. The family plot is located on the grounds of that original grant, the estate of Crooked Intention. (Courtesy of Robert Shockley.)

Who doesn't like an old-fashioned birthday party with ice cream, cake, and balloons? These children are having a good time as seen in this 1950s photograph in one of the venerable older homes in town. The St. Michaels area continues to attract parents today as it offers a quiet, bucolic setting in which to raise families. (Courtesy of the Talbot County Historical Society.)

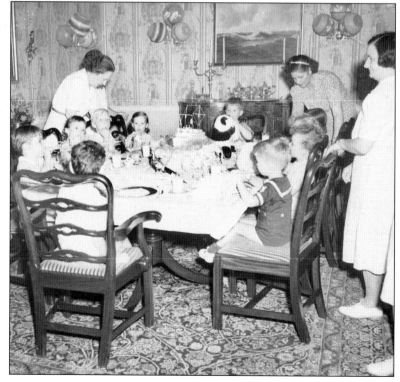

110

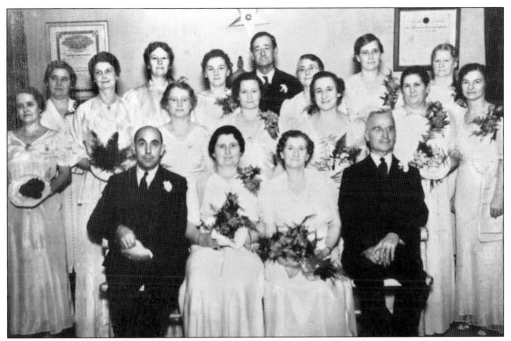

Here is a grand gathering of a Women's Club party c. 1942, held at the Masonic Lodge in town. The Women's Club had an office on Talbot Street until a fire decimated the building; the current location is on St. Mary's Square. (Courtesy of the Talbot County Historical Society.)

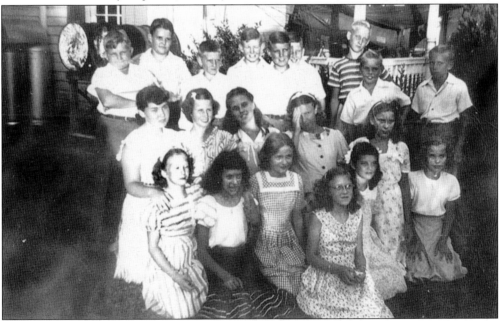

This early-1950s gathering of children in St. Michaels includes, from left to right, (first row) Laura Morris, Nancy Harrison, Joann Sewell, Sylvia Griffith, and Esther Hause; (second row) Charlene Brewster, two unidentified, Evelyn Harrison, and Adeline Mothershead; (third row) Jack Colmon, Townsend Parkinson, King Hall, Alan Hudson, Francis Hudson, Robert Shockley, Jon Berry, Duke Shannahan, and Val Shannahan. (Courtesy of Robert Shockley.)

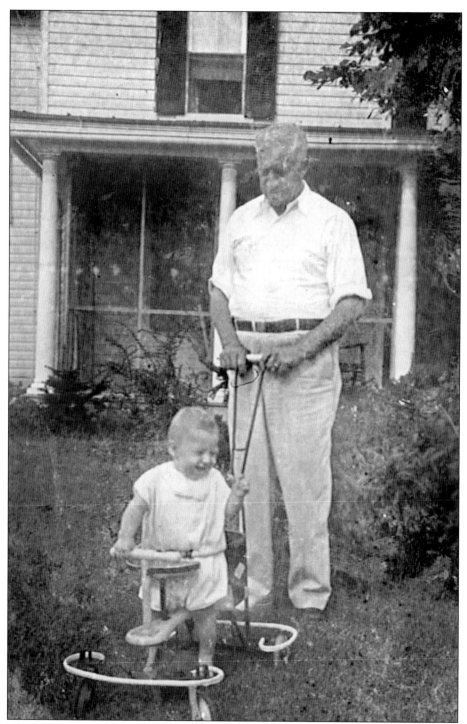

Bob Shockley and his father, David Herman Shockley, are seen at home in St. Michaels in 1938. David Shockley managed the American Store until the Great Depression, then owned his own grocery store until the 1950s, and after that he ran a corner drugstore and soda fountain in town until 1961. (Courtesy of Robert Shockley.)

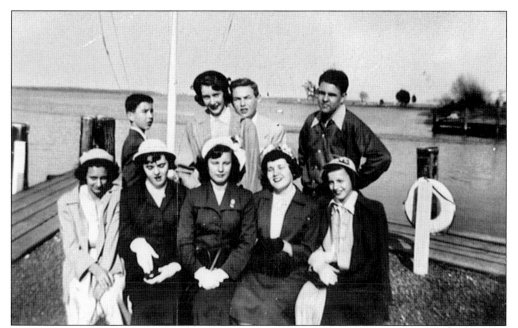

It's Easter Sunday in this photograph from 1953, and these friends from St. Michaels High School are posing on the wharf at the harbor where the Town Dock and Longfellows restaurants are located today. From left to right are (first row) Nancy Harrison, Jane Ross, Evelyn Harrison, Charlene Brewster, and Lorraine Barth; (second row) Carl Truitt, Jean Borcherding, George Truitt, and Townsend Parkinson. (Courtesy of Robert Shockley.)

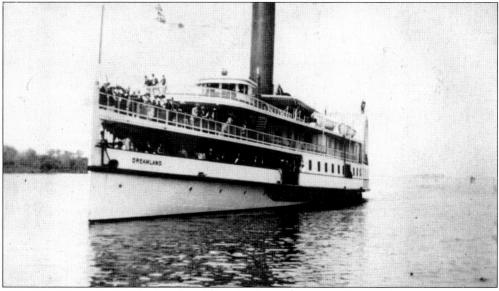

The *Dreamland* was a luxury passenger steamer from Baltimore that made stops in the St. Michaels area. The first steamboat to paddle up the Miles River in 1817 was a much simpler version: a flat-bottomed rig where the livestock, freight, and passengers traveled together. By the late 1870s, steamboats were built to provide passengers with dining facilities and private rooms and were a preferred means of travel from the western to the eastern shores up until the 1930s. (Courtesy of the Talbot County Historical Society.)

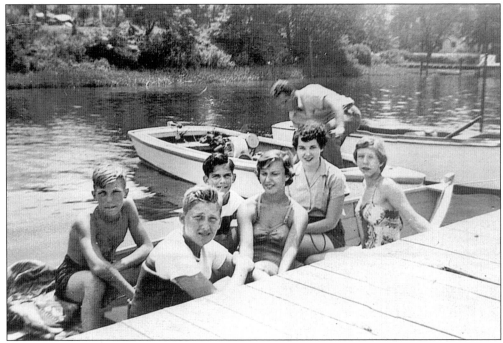

Swimming and rowing on a warm day with friends is a pleasant way to spend the summer. This photograph was taken on Long Haul Creek in the 1950s and features, from left to right, Kendall Messick, Bob Shockley, Bernie Ames, Evelyn Harrison, Charlene Brewster, and Laura Morris. (Courtesy of Robert Shockley.)

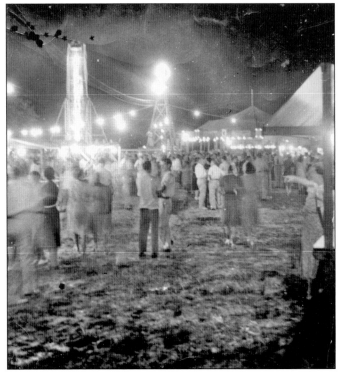

The Carnival, sponsored by the St. Michaels Volunteer Fire Company, is an eagerly anticipated summertime event held just outside of town and offering the traditional local fare along with rides, games, and prizes. This photograph is a nighttime shot taken in the mid-1970s of the carnival grounds in full swing. (Courtesy of the St. Michaels Volunteer Fire Department.)

James Michener was photographed on the Honeymoon footbridge connecting Cherry Street with Navy Point in the late 1970s to promote his novel *Chesapeake*. Today this view would show more pleasure craft than workboats. (Courtesy of the Talbot County Free Library.)

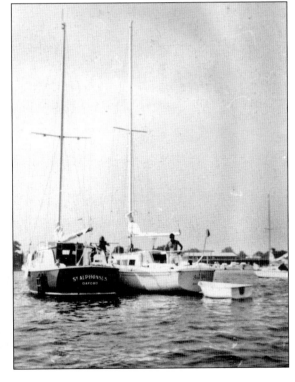

Sailing enthusiasts have always found the harbor area a pleasant haven for mooring; boats can still put in at the St. Michaels harbor for a weekend. If one cannot find a spot at the town dock, then anchoring just out of the channel traffic is permissible, as seen in this photograph from 1975. (Author's collection.)

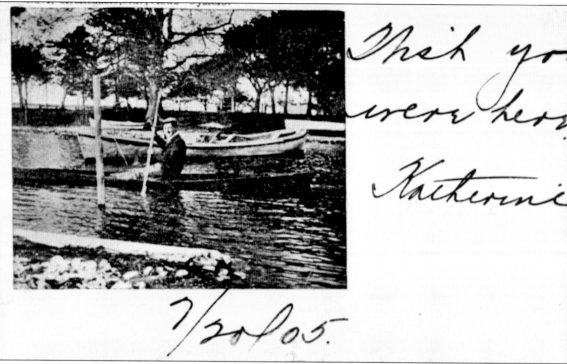

This "Wish You Were Here" postcard dates from 1905; St. Michaels' popularity as a vacation destination for visitors from the western shore reached its peak from 1880 to the 1920s. The tourism trade was on the rise at about the same time as the decline of the oyster industry. (Courtesy of the St. Michaels Museum at St. Mary's Square.)

Ten

RIGS AND REGATTAS

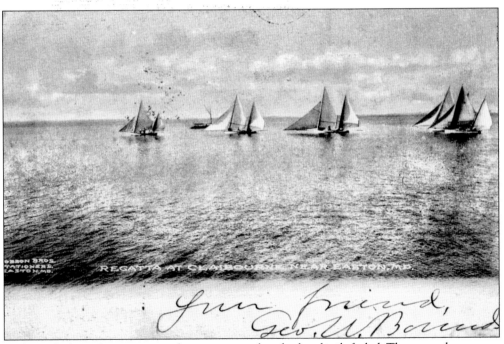

In the early days of regatta races, the canoes were beached and sails furled. The crews then met at a certain point on land to wait for the starting signal. The entertainment usually began at the start when competitive teams full of hot tempers and foul language raced to be the first rigged up and in the water. The regattas remain, in somewhat milder form, a high point of the summer for those interested in boats and sailing. (Courtesy of the St. Michaels Museum at St. Mary's Square.)

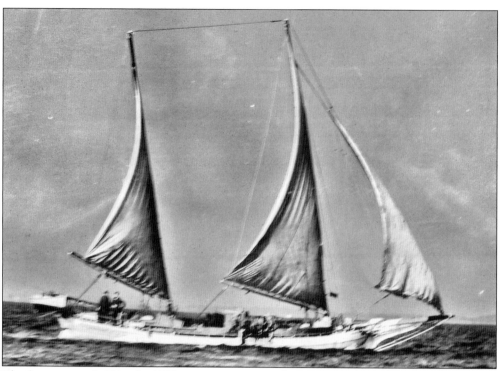

The first regattas held in the 1800s were competitions between the skipjack captains to see who could race into the harbor fastest; those who arrived first were able to sell their catch at a better price. This is a *c.* 1930 photograph of a skipjack under sail and at work. (Courtesy of the Talbot County Free Library.)

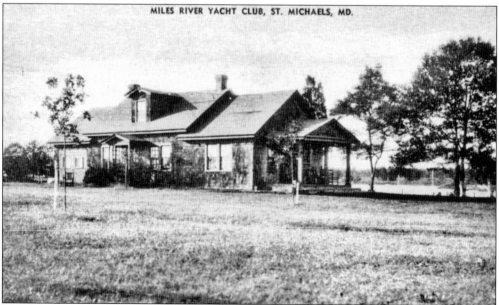

MILES RIVER YACHT CLUB, ST. MICHAELS, MD.

Miles River Yacht Club formed in 1923 and held its first canoe races the same year. It still sponsors the annual Miles River Regatta and offers classes in sailing, seamanship, and swimming as well as docking for members and guests. (Courtesy of the St. Michaels Museum at St. Mary's Square.)

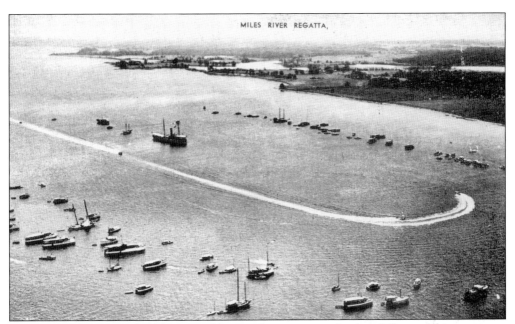

Regattas are boat races held by type of boat and experience of sailors. Those who just want to watch drop anchor and enjoy the races. It is as much an event to see as a place to be seen, as people parade their boats large and small around the harbor, festooned with flags. The harbor at St. Michaels is particularly suited to this type of event with its broad vista of the Miles River. (Courtesy of the St. Michaels Museum at St. Mary's Square.)

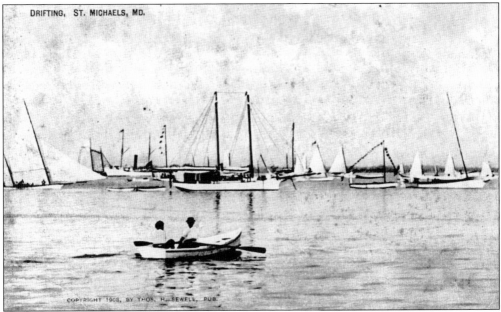

DRIFTING, ST. MICHAELS, MD.

COPYRIGHT 1908, BY THOS. H. SEWELL, PUB.

This postcard entitled "Vacationland" depicts a regatta harbor scene, probably at the end of the race. Boats usually come into harbor to celebrate the winners and fete the crewmembers for their hard work. Around the early 20th century, the regattas were part of a larger celebration, held in August, that also featured ball games, contests, and musical entertainment. (Courtesy of the St. Michaels Museum at St. Mary's Square.)

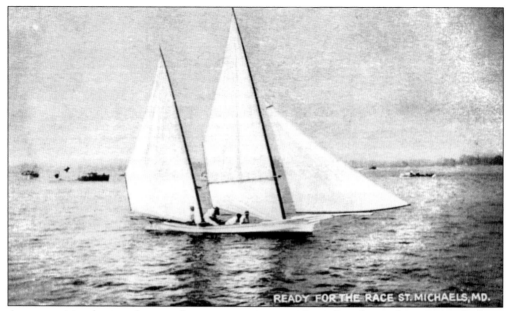

As competition became keener, the racing canoes were less often the working oyster dredgers and became more streamlined and polished for a faster race. The basic construction is still the same, notably three sails—foresail, mainsail, and jib—and possibly a spinnaker. The masts are stepped to allow for adjustments as needed; weather, as always, dictates the rigging. (Courtesy of the St. Michaels Museum at St. Mary's Square.)

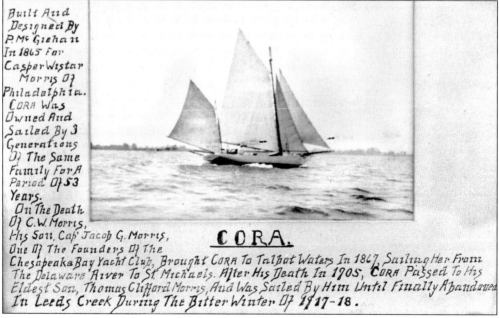

Built And Designed By P. McGiehan In 1865 For Casper Wistar Morris Of Philadelphia. CORA Was Owned And Sailed By 3 Generations Of The Same Family For A Period Of 53 Years. On The Death Of C. W. Morris, His Son, Cap' Jacob G. Morris, One Of The Founders Of The Chesapeaka Bay Yacht Club, Brought CORA To Talbot Waters In 1867, Sailing Her From The Delaware River To St. Michaels. After His Death In 1905, CORA Passed To His Eldest Son, Thomas Clifford Morris, And Was Sailed By Him Until Finally Abandoned In Leeds Creek During The Bitter Winter Of 1917-18.

CORA.

Boats were often passed down in families, as *Cora* was. She was built in 1865, not as a working vessel but as a pleasure sailing craft. Her story here states that she was owned and sailed "from the Delaware River to St. Michaels" by three generations of the same family for 53 years until she was abandoned in Leeds Creek across the Miles River from St. Michaels. (Courtesy of the Talbot County Free Library.)

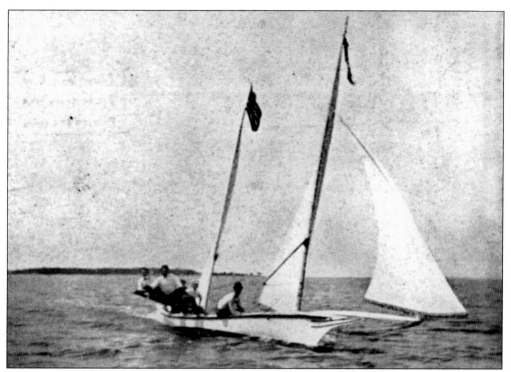

Log canoes evolved from being made of a hollowed-out tree trunk by the Native Americans, to a modified planking construction that involved several slabs of wood carved together, to the current method, which involves more modern construction resulting in a lighter, swifter racing boat. (Courtesy of the St. Michaels Museum at St. Mary's Square.)

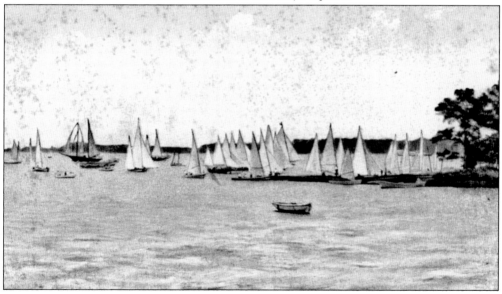

This postcard view shows the start of the race off of Parrott's Point north of the harbor. Parrott's Point holds its place in the history of the area as the munitions arsenal that the British had their eyes on when they attacked the town of St. Michaels. This view is from a postcard dating around 1906. (Courtesy of the St. Michaels Museum at St. Mary's Square.)

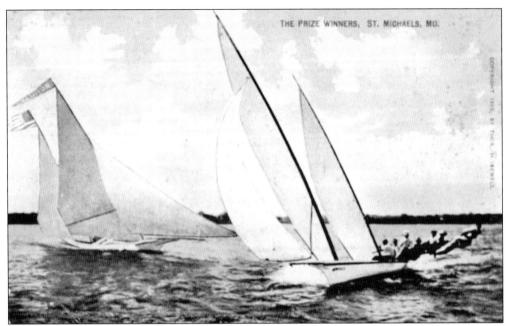

Why the boards? It is simply a matter of keeping the boat from tipping; the planks (which are called hiking boards) are about 12 feet long, and as the sheets (sails) are pulled tight to catch the wind, it creates an undue imbalance on the opposite side. The crew can correct this by scooting out on the boards. It always makes for a more exciting race if the hiking boards are utilized, but don't expect to see too many fall overboard; much training is required in order to be part of a crew. (Author's collection.)

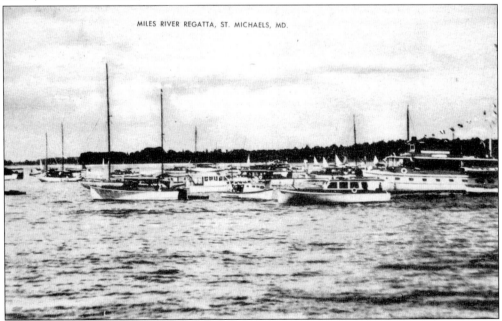

This postcard from 1907 shows many different boats participating in the regatta, but in the early days of boat racing, it was just the captains and crews of the working skipjacks who engaged in a little competition during the summer. (Courtesy of the St. Michaels Museum at St. Mary's Square.)

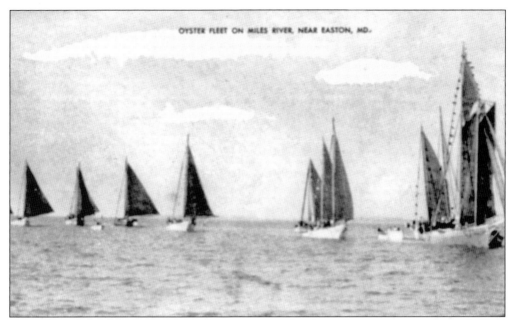

It is believed that by 1840, organized races among the skipjack captains were being held in St. Michaels. There were no special boats for racing, only the workaday boats used in fishing and oystering. Regattas were usually held on the Fourth of July, 30 starters not being unheard of, with a silver cup as the prize for the winner. (Courtesy of the St. Michaels Museum at St. Mary's Square.)

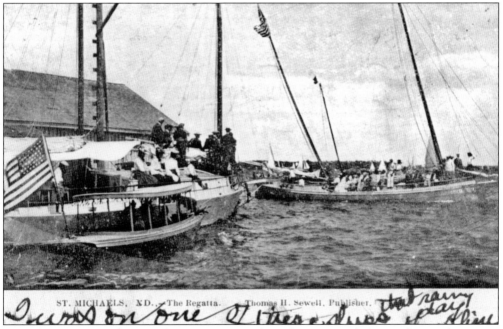

Regattas are a true indicator of summertime. Both working rigs and pleasure boats take part in the races, which usually take place over a weekend. Today there are several races sponsored by the different yacht clubs both on the Miles and Tred Avon Rivers. (Courtesy of the St. Michaels Museum at St. Mary's Square.)

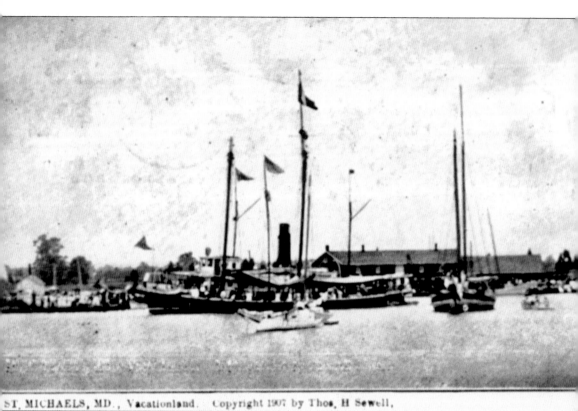

ST. MICHAELS, MD., Vacationland. Copyright 1907 by Thos. H Sewell,

The charm of the regattas lies not only in the racing but also as an event to see boats new and antique. In this old postcard from 1907, one can see the parade of boats in the harbor. (Courtesy of the St. Michaels Museum at St. Mary's Square.)

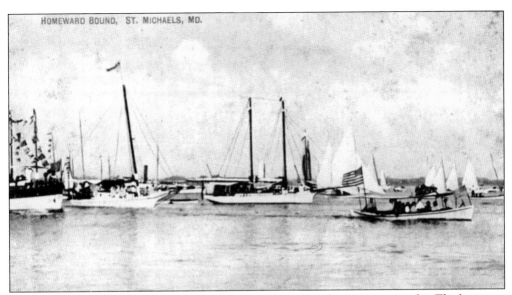

HOMEWARD BOUND, ST. MICHAELS, MD.

At the end of the race, there is an awards ceremony, with a silver cup as a trophy. The boats are then retired to their usual moorings, ready for work the next day or to be prepared for the next race. (Courtesy of the St. Michaels Museum at St. Mary's Square.)

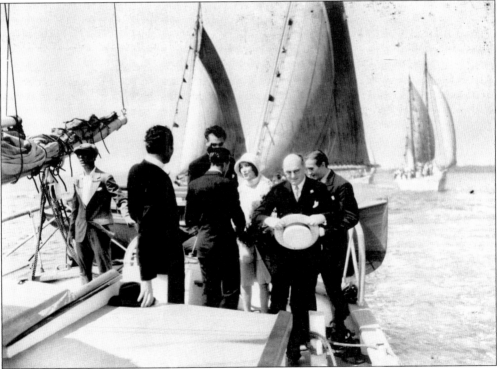

This is a production photograph of Fay Wray and Gary Cooper on board during filming of their silent film *First Kiss*. The two stars can barely be seen in the crowd, but the sails in the background make for an interesting shot of how a movie scene was set up in 1928. The boats in the background were all working skipjacks from the fleet in St. Michaels. (Courtesy of the Talbot County Historical Society.)

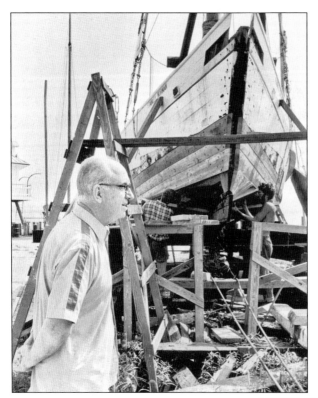

Here is James Michener striking a pose in front of a skipjack undergoing repairs on Navy Point in the late 1970s. Michener was a part-time resident and occasional presence during his time in St. Michaels. The few pictures that exist of him were taken for publicity purposes to promote his fictional novel *Chesapeake* after it was published. (Courtesy of the Talbot County Free Library.)

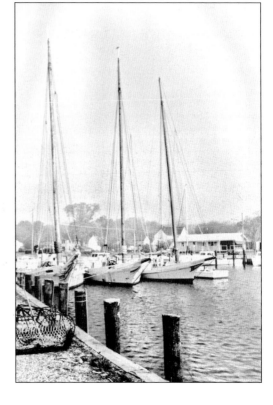

A trio of skipjacks are moored in the harbor on Tilghman Island. The oyster scrape is in the foreground. Sadly, with the innovations in boatbuilding in recent times, many skipjacks were left to rot in coves or shallow waters. Today there are only 19 skipjacks sailing the waters of the Chesapeake Bay. (Courtesy of the St. Michaels Museum at St. Mary's Square.)

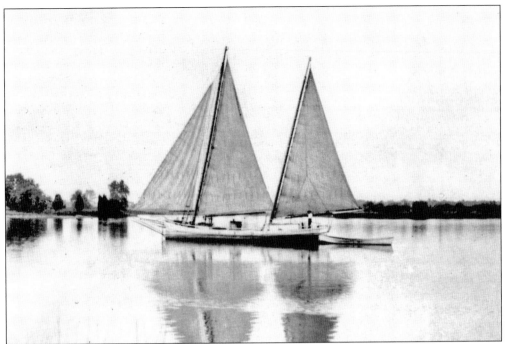

After the 1930s, images such as these of a skipjack at work under full sail became less common. In a few places such as Tilghman and Deal Island, one can see these magnificent working boats, which are now under state protection as historic landmarks. (Courtesy of the St. Michaels Museum at St. Mary's Square.)

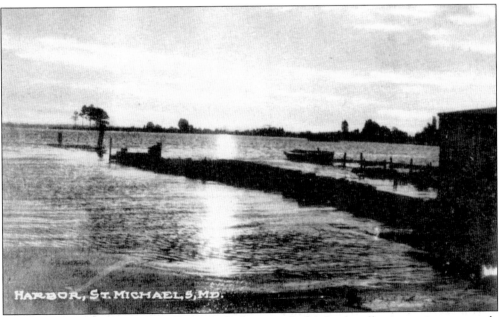

HARBOR, ST. MICHAELS, MD.

Those lucky enough to be able to live or spend time in St. Michaels will enjoy seeing some truly magnificent sunsets, the beauty of which cannot quite be conveyed by this black-and-white postcard of the St. Michaels harbor in 1907. (Author's collection.)

ACROSS AMERICA, PEOPLE ARE DISCOVERING SOMETHING WONDERFUL. THEIR HERITAGE.

Arcadia Publishing is the leading local history publisher in the United States. With more than 3,000 titles in print and hundreds of new titles released every year, Arcadia has extensive specialized experience chronicling the history of communities and celebrating America's hidden stories, bringing to life the people, places, and events from the past. To discover the history of other communities across the nation, please visit:

www.arcadiapublishing.com

Customized search tools allow you to find regional history books about the town where you grew up, the cities where your friends and family live, the town where your parents met, or even that retirement spot you've been dreaming about.